Remembering
Kansas City

Lara Copeland

TURNER
PUBLISHING COMPANY

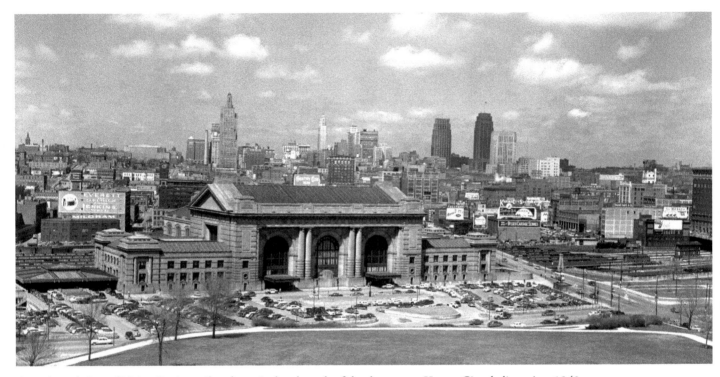

A southward view of Union Station railroad terminal and much of the downtown Kansas City skyline, circa 1940s.

Remembering
Kansas City

Turner Publishing Company
www.turnerpublishing.com

Remembering Kansas City

Library of Congress Control Number: 2010902282

ISBN: 978-1-59652-609-9

Printed in the United States of America

ISBN 978-1-68336-844-1 (pbk.)

CONTENTS

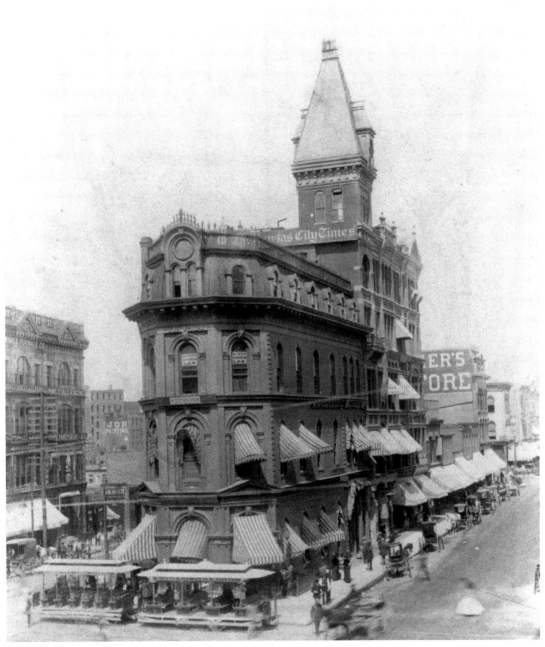

A view to the northwest in 1886 from the southeast corner of Ninth and Main includes the Kansas City Times building. Cable cars are identified as belonging to the Kansas City Cable Railway, which operated from 1885 to 1906.

Acknowledgments

This volume, *Remembering Kansas City*, is the result of the cooperation and efforts of many individuals and organizations. It is with great thanks that we acknowledge the valuable contribution of the following for their generous support:

First Federal Bank of Kansas City
Hotel Phillips
Kansas City Public Library
Missouri State Archives
Saint Luke's Health System

We would also like to thank the following individuals for their valuable contributions and assistance in making this work possible:

Mary Beveridge, Missouri Valley Special Collections, Kansas City Public Library
Laura Jolley, Missouri State Archives

PREFACE

Kansas City has thousands of historic photographs that reside in archives, both locally and nationally. This book began with the observation that, while those photographs are of great interest to many, they are not easily accessible. During a time when Kansas City is looking ahead and evaluating its future course, many people are asking, How do we treat the past? These decisions affect every aspect of the city—architecture, public spaces, commerce, tourism, recreation, and infrastructure—and these, in turn, affect the way that people live their lives. This book seeks to provide easy access to a valuable, objective look into Kansas City's history.

The power of photographs is that they are less subjective than words in their treatment of history. Although the photographer can make subjective decisions regarding subject matter and how to capture and present it, photographs seldom interpret the past to the extent textual histories can. For this reason, photography is uniquely positioned to offer an original, untainted look at the past, allowing the viewer to learn for himself what the world was like a century or more ago.

This project represents countless hours of research and review. The researchers and writer have reviewed thousands of photographs in numerous archives. We greatly appreciate the generous assistance of the archivists listed in the acknowledgments of this work, without whom this project could not have been completed.

The goal in publishing this work is to provide broader access to a set of extraordinary photographs that seek to inspire, provide perspective, and evoke insight that might assist people who are responsible for determining Kansas City's future. In addition, the book seeks to preserve the past with adequate respect and reverence.

The photographs selected have been reproduced using multiple inks to provide depth to the images. With the

exception of touching up imperfections that have accrued with the passage of time and cropping where necessary, no changes have been made. The focus and clarity of many images is limited by the technology and the ability of the photographer at the time they were taken.

The work is divided into eras. Beginning with some of the earliest known photographs of Kansas City, the first section takes a look at the city from the 1860s to the end of the nineteenth century. The second section spans the beginning of the twentieth century through World War I. Section Three moves from 1920 to the eve of World War II. And finally, Section Four covers the 1940s to the 1960s.

In each of these sections we have made an effort to capture various aspects of life through our selection of photographs. People, commerce, transportation, infrastructure, religious institutions, educational institutions, and scenes of natural beauty have been included to provide a broad perspective.

It is the publisher's hope that in utilizing this work, longtime residents will learn something new and that new residents will gain a perspective on where Kansas City has been, so that each can contribute to its future.

—*Todd Bottorff, Publisher*

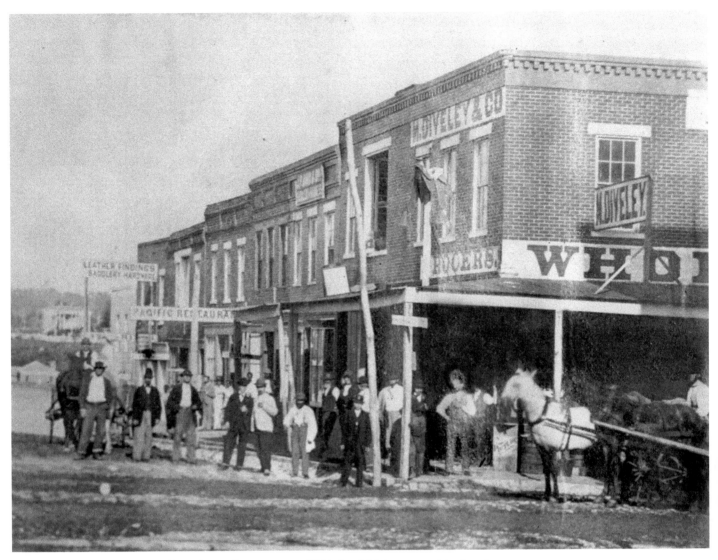

Identified as looking southeast from the northwest corner of Third and Main streets, this view shows the Pacific Restaurant, as well as the M. Diveley and Company Grocers building on the corner.

To the End of the Nineteenth Century

(1860s–1899)

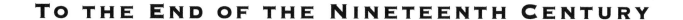

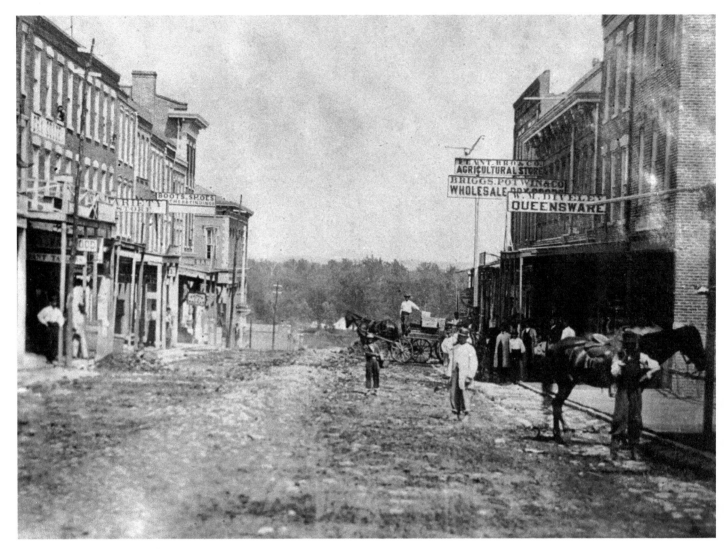

An 1867 view of Main Street looking north from Third Street.

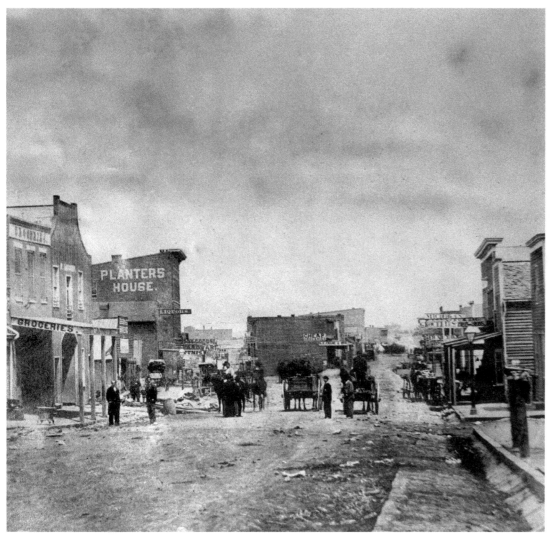

An 1867 view looking north on Main Street toward the Junction. The Planters' House, founded by Jacob Keefer, is seen toward the back.

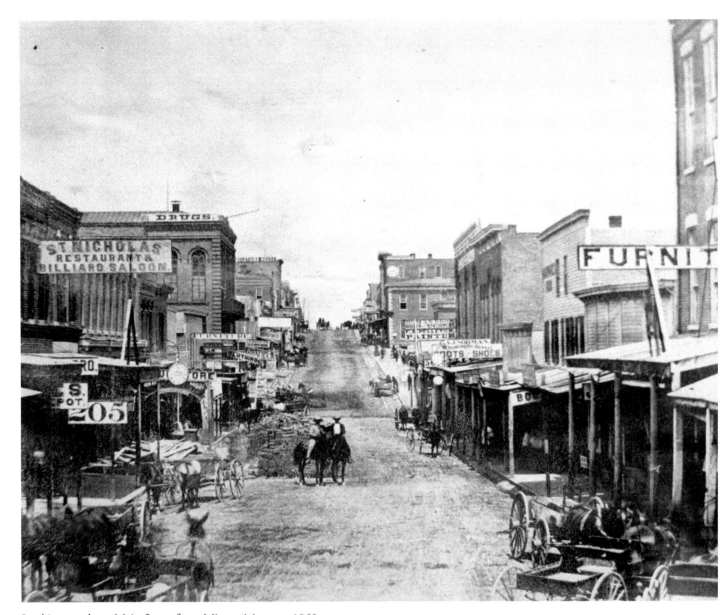

Looking north on Main Street from Missouri Avenue, 1868.

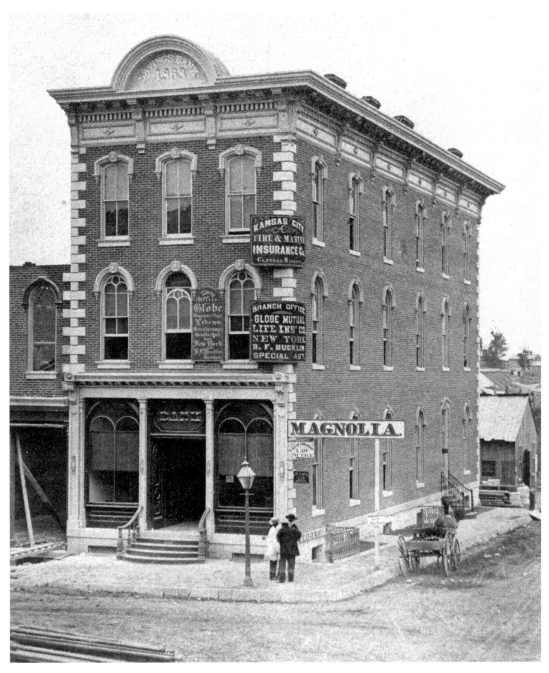

The Kansas City Savings Association building in 1868. The bank opened with the end of the Civil War in 1865 in this narrow, three-story brick building.

An 1880 northward view of Union Depot, built in 1877.

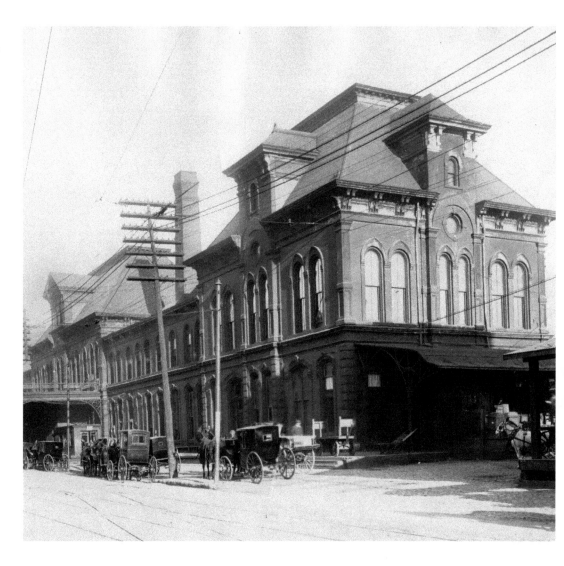

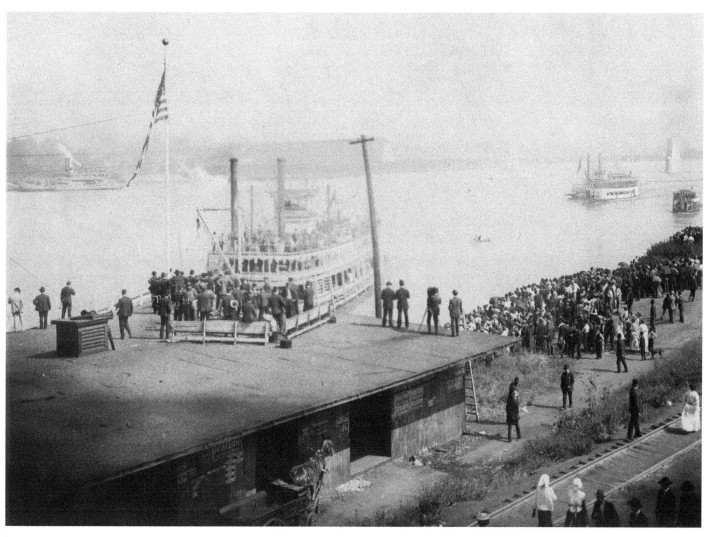

A group of people gather to watch steamboats on the Missouri River at the foot of Main Street, circa 1880. The first steamboats to navigate the upper Missouri were used in 1819, and they continued to be used in order to exchange goods from the east for goods from the west.

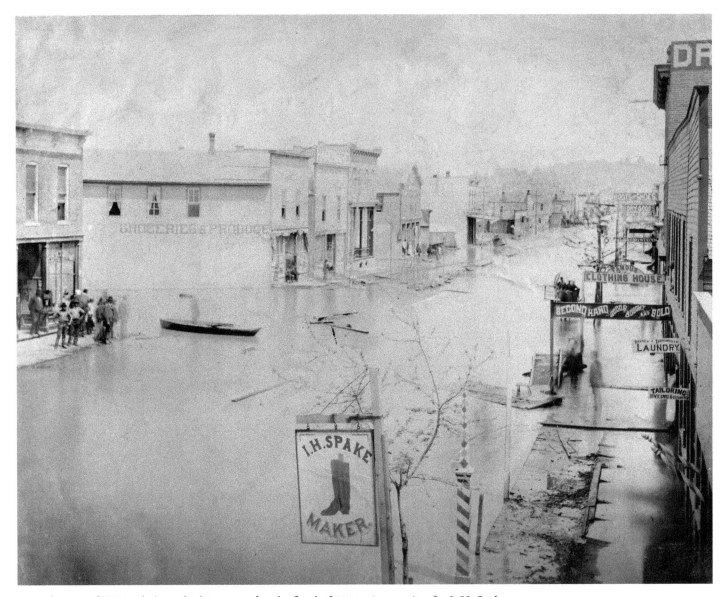

An early view of W. Ninth Street looking east, after the flood of 1881. A store sign for I. H. Spake, an early shoe repairman, hangs above the floodwaters.

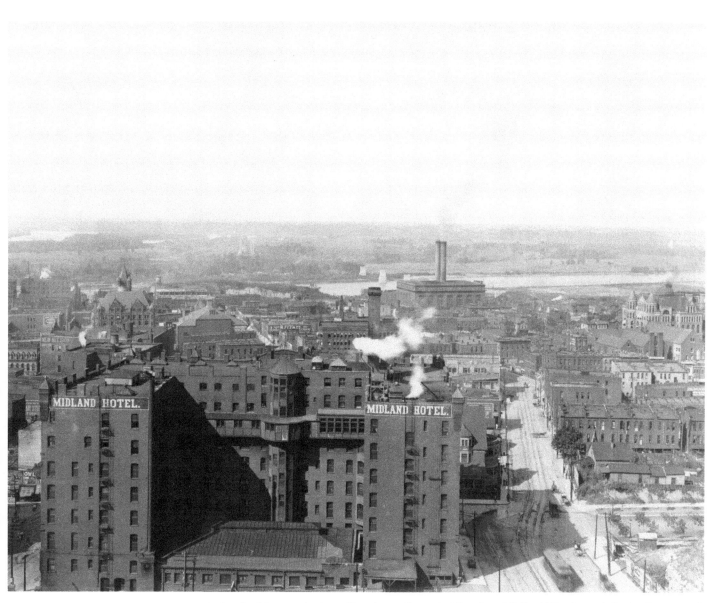

A view looking north along Grand near Seventh. The giant Midland Hotel stands in the foreground.

A northward view of the Vaughan's Diamond Building is shown here on Main Street from the south side of Ninth Street at the Junction, circa 1885. The first floor has the Grand Junction Ticket Office for the Chicago and Alton Railroad; Kansas City, Fort Scott, and Memphis Railroad; and Chicago, St. Paul and Kansas City Railroad.

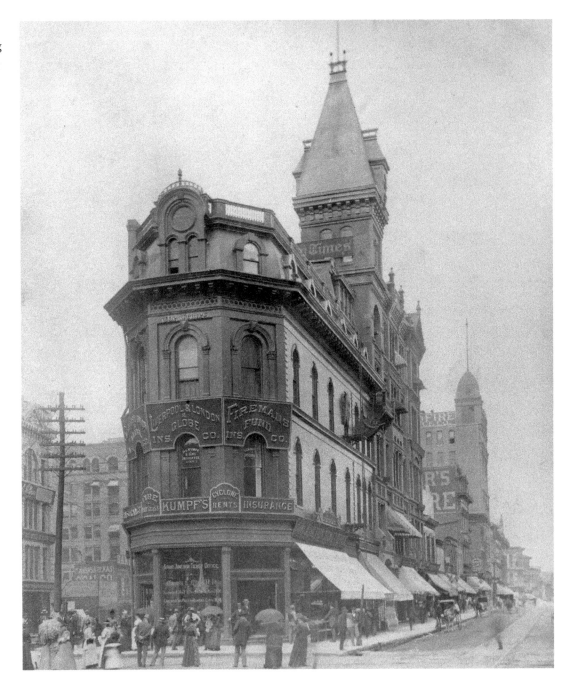

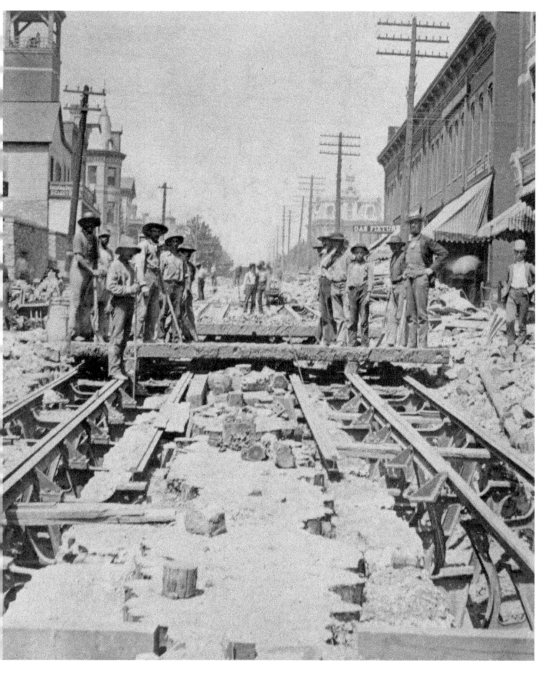

Although the first cable cars started operation in 1883, a group of men are seen here laying cable car tracks along 12th Street in 1886. The First Baptist Church is in the background at 12th and Baltimore.

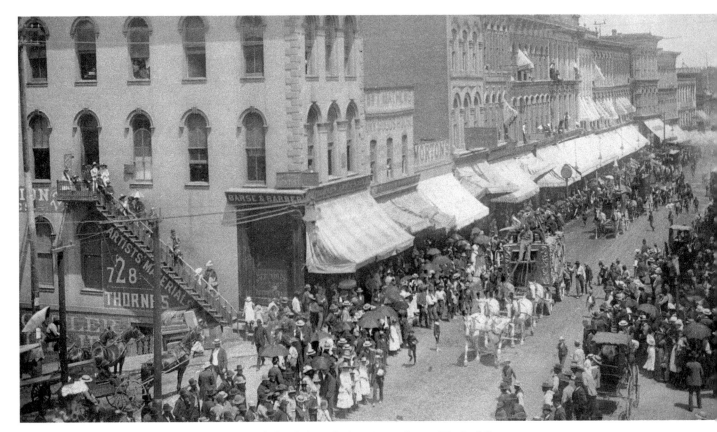

An 1886 photograph of the Barnum Circus parade headed south along Main Street. The building in the forefront was reportedly the first location for the public library, in 1874. Morton's; Barse and Barber; and Mathews Dry Goods House are a few of the visible storefronts.

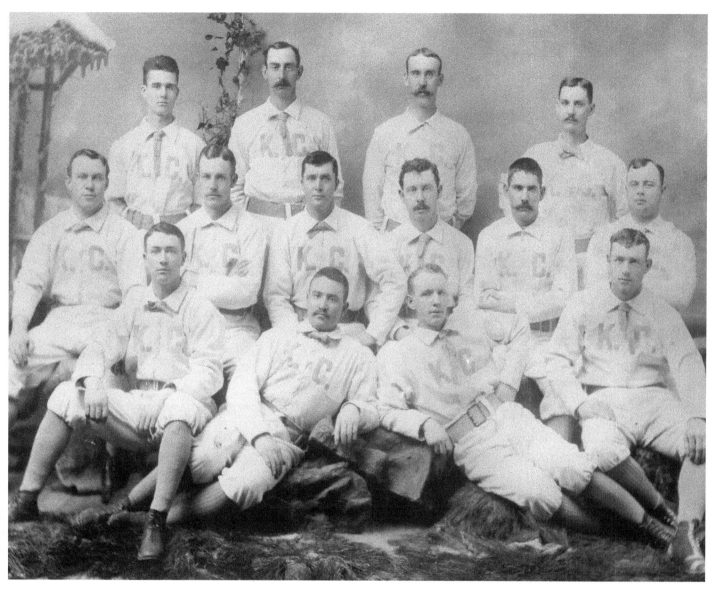

Kansas City Baseball Club members in 1886.

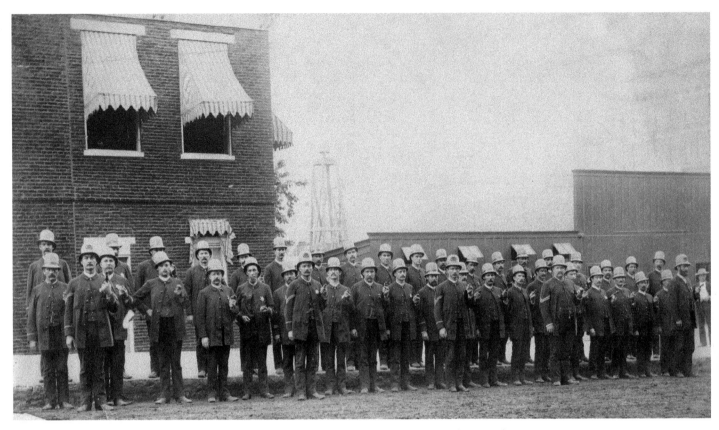

Captain Branham, at right, is the only identified Kansas City police officer in this 1886 photograph. Identified in the background is the old City Hall.

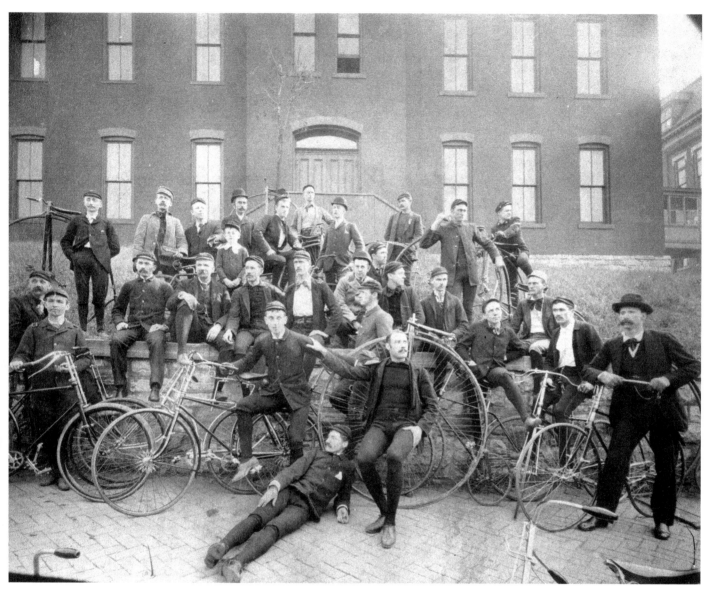

Members of the Kansas City Bicycle Club pose with their bicycles.

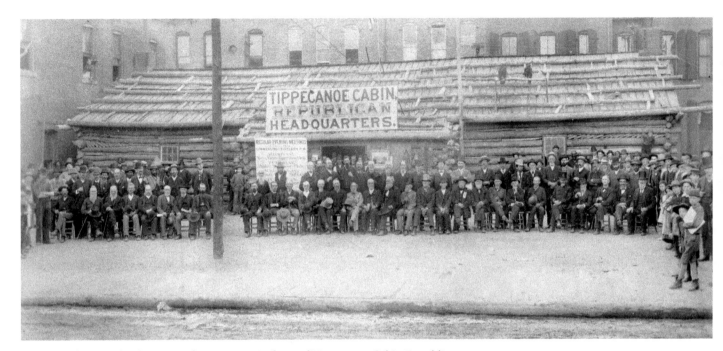

An 1888 photograph of a group of men posing in front of Tippecanoe Cabin Republican Headquarters located at 1110 Walnut. Colonel Robert T. Van Horn is identified as sitting in the eighth chair to the right of the pole.

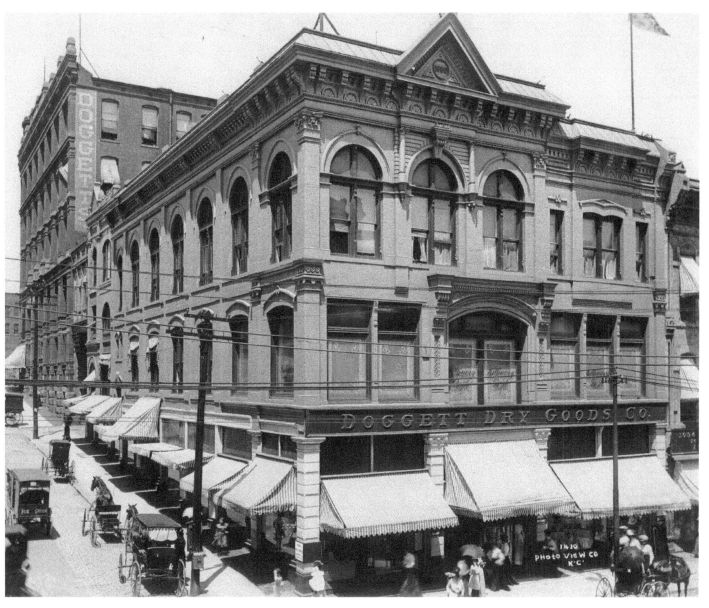

A view of Doggett Dry Goods Company building located at 1044 Main Street in 1890. John Doggett, owner, opened his first store in Kansas City in 1866. Later, in 1893, George B. Peck bought out Doggett's interest, and the store's name changed to George B. Peck Dry Goods Company in 1901. The store survived until 1964.

A view of the corner of the Boley building at 12th and Walnut.

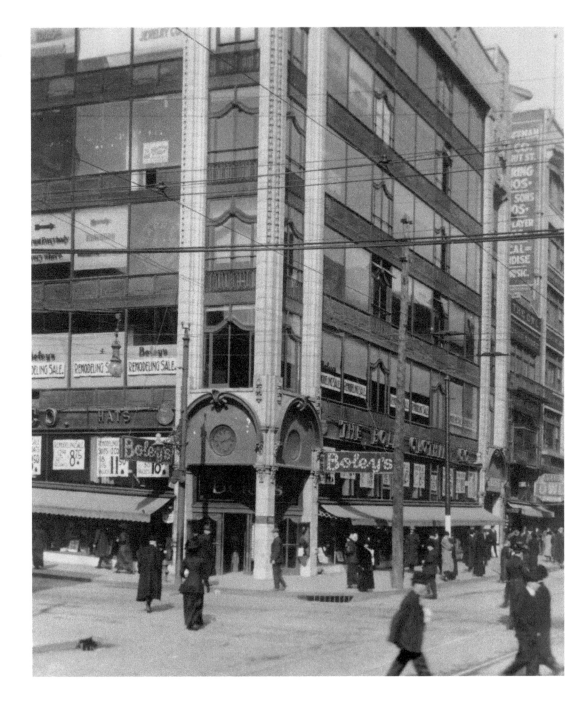

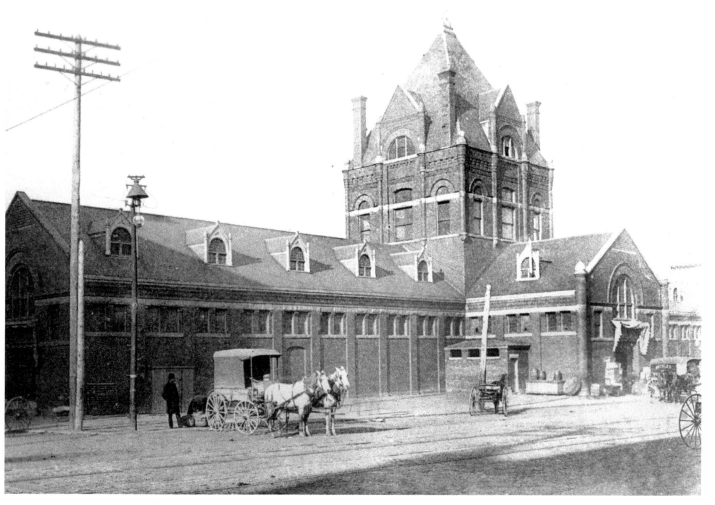

An 1890 photograph of Old City Market building.

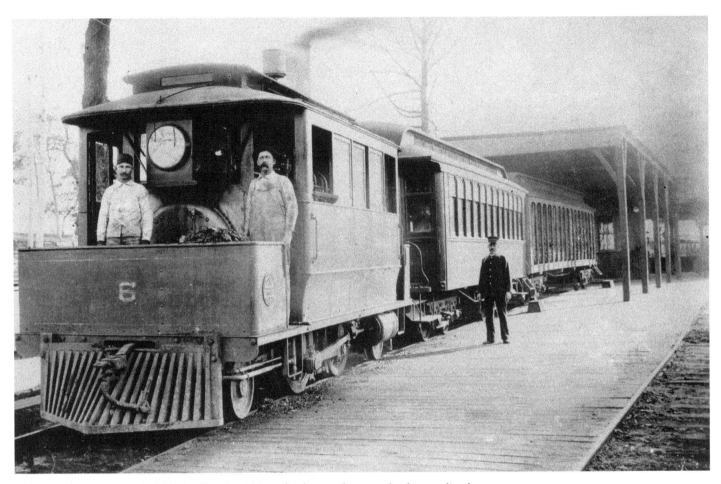

Three employees pose with Old Number 6 at 15th and Askew as they run the dummy line between Independence and Kansas City.

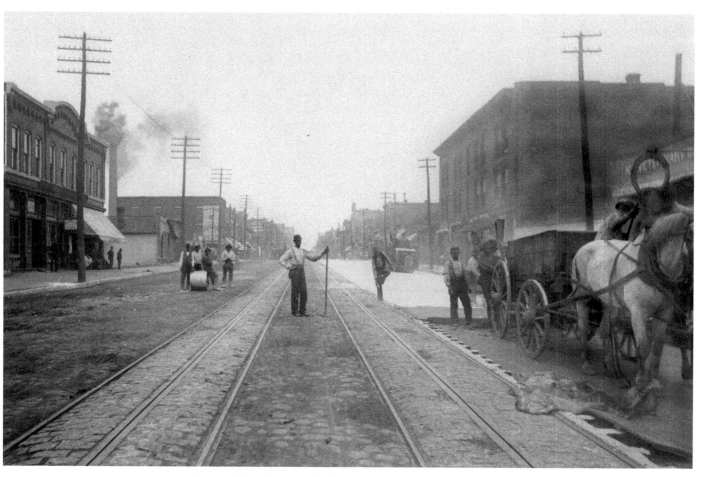

A view of Grand Avenue looking north from 18th Street. M. K. Goetz Brewing Company is visible in front and to the left. Michael Karl Goetz was a German immigrant who started the company in 1859, which was in business until 1976.

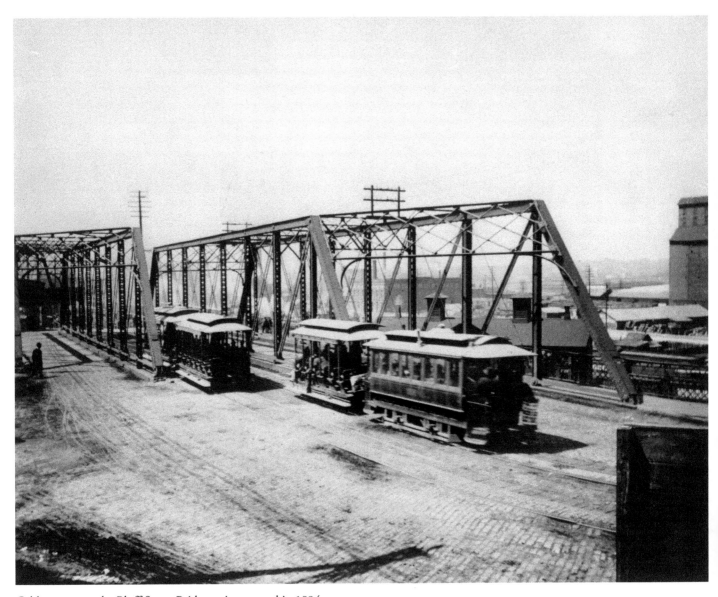

Cable cars cross the Bluff Street Bridge as it appeared in 1894.

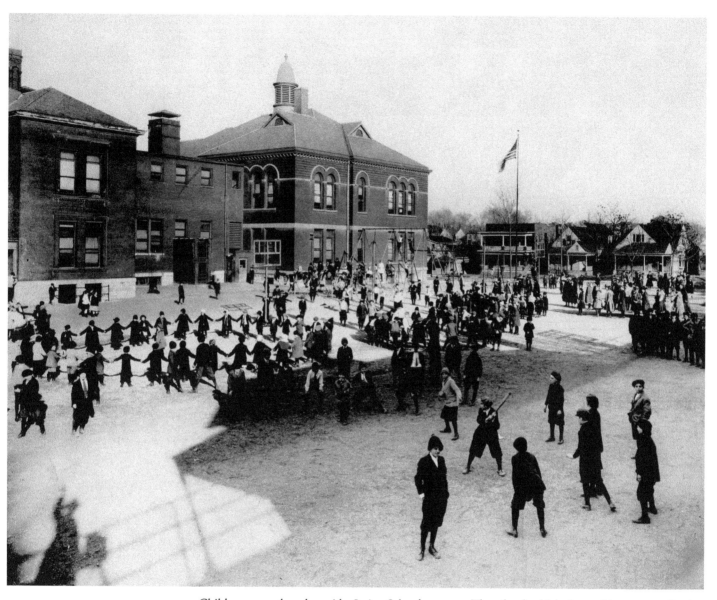

Children are gathered outside Irving School at recess. The school, which changed its name to Booker T. Washington in 1942, was located at 24th and Prospect.

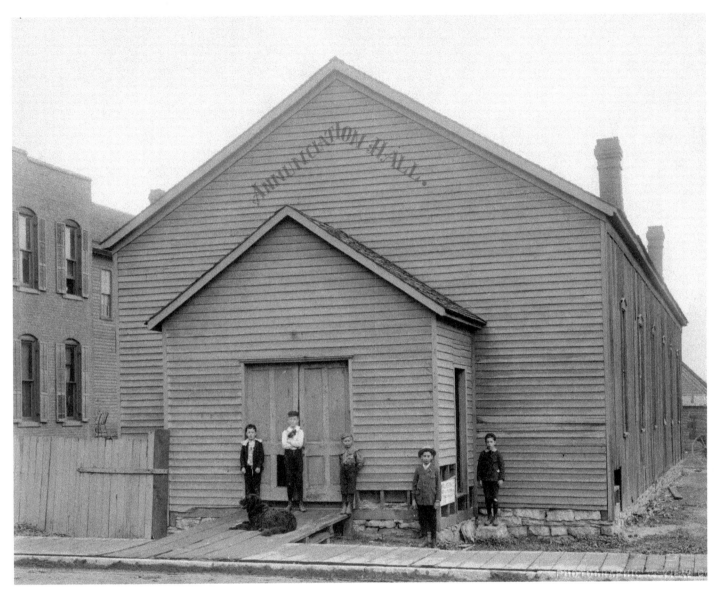

Children pose for the camera outside Annunciation Hall.

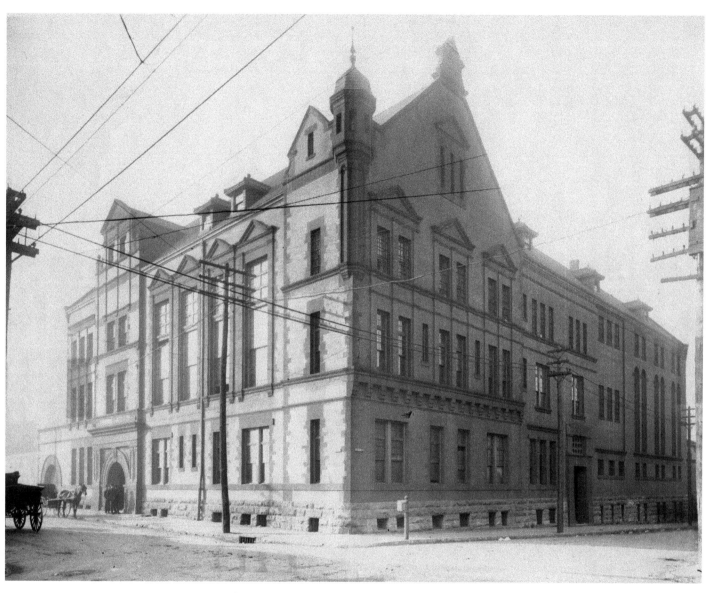

A view of the Kansas City Jail.

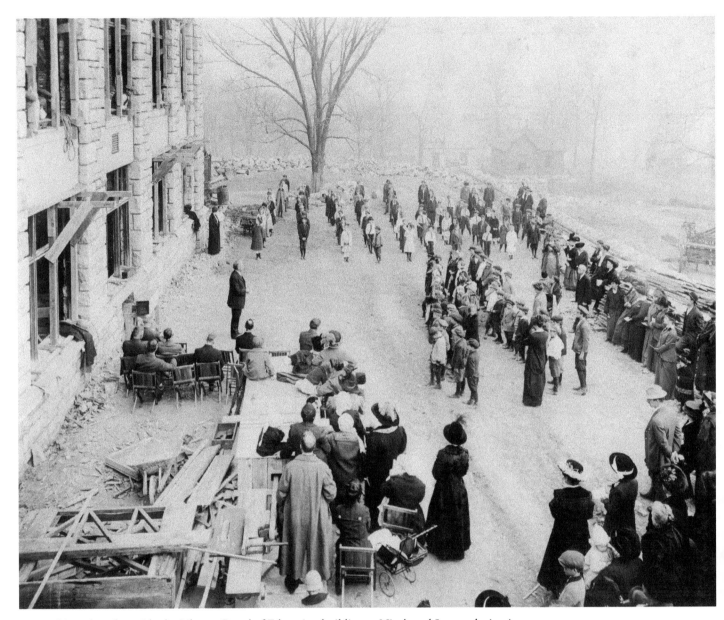

A crowd is gathered outside the Library–Board of Education building at Ninth and Locust during its dedication ceremony, circa 1897.

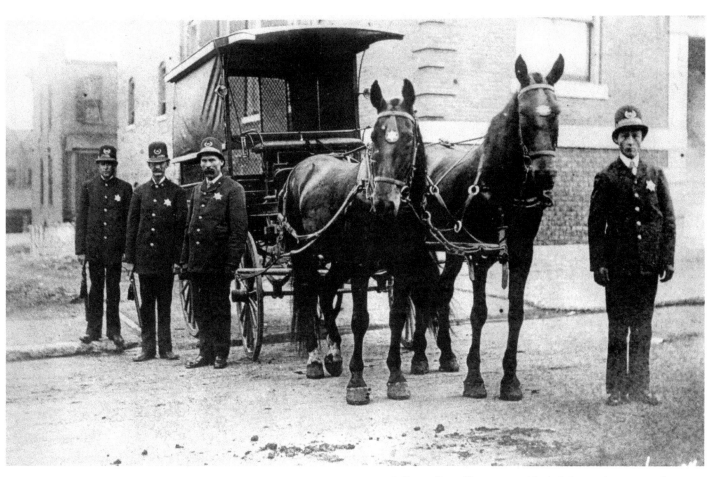

A few police officers pose with their horse-drawn patrol wagon.

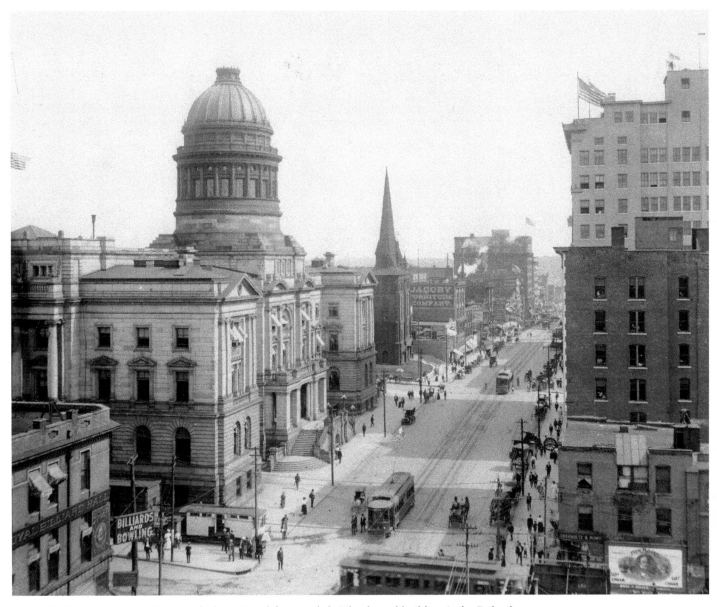

A July 1908 photograph looking south along Grand from Eighth. The domed building is the Federal Building. Also pictured is the Grand Avenue Methodist Church with its tall steeple just south of the Federal Building.

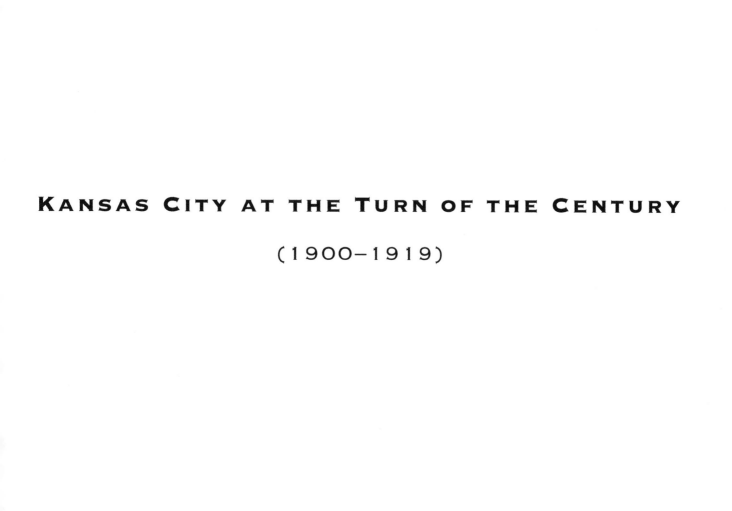

KANSAS CITY AT THE TURN OF THE CENTURY

(1900–1919)

A view of the Altman building, located on the southeast corner of 11th and Walnut.

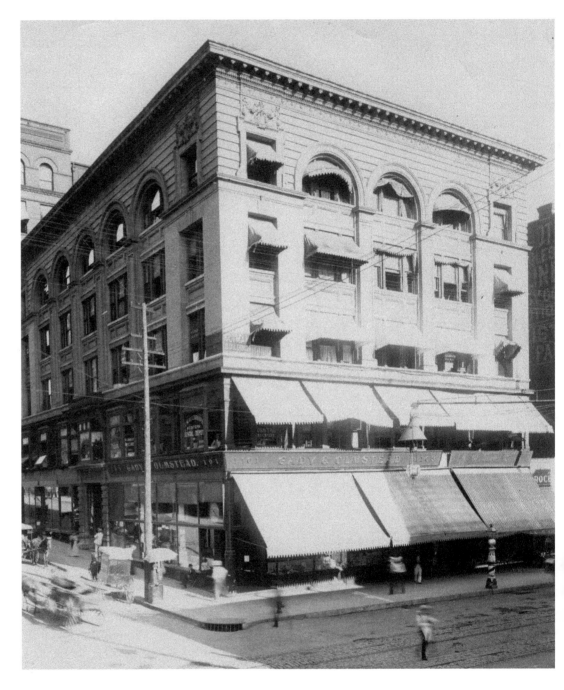

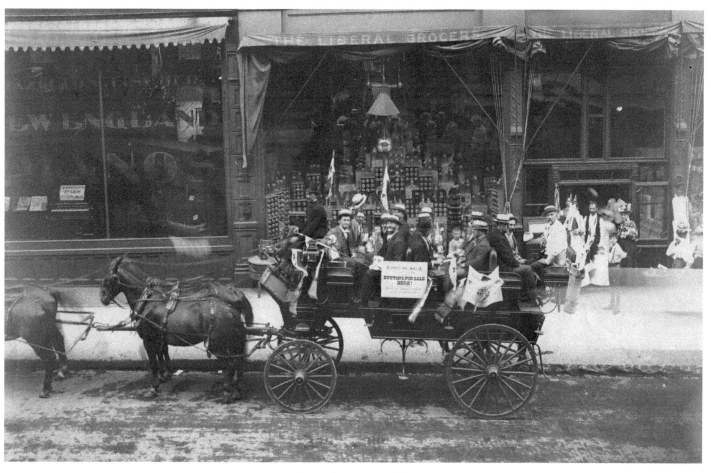

Men sit atop a horse-drawn wagon bearing a sign that reads "It Costs One Dollar to Talk to Me: Buttons for Sale Here: Kansas City Admirer's Association." Silverman Brothers grocery store is visible behind the wagon.

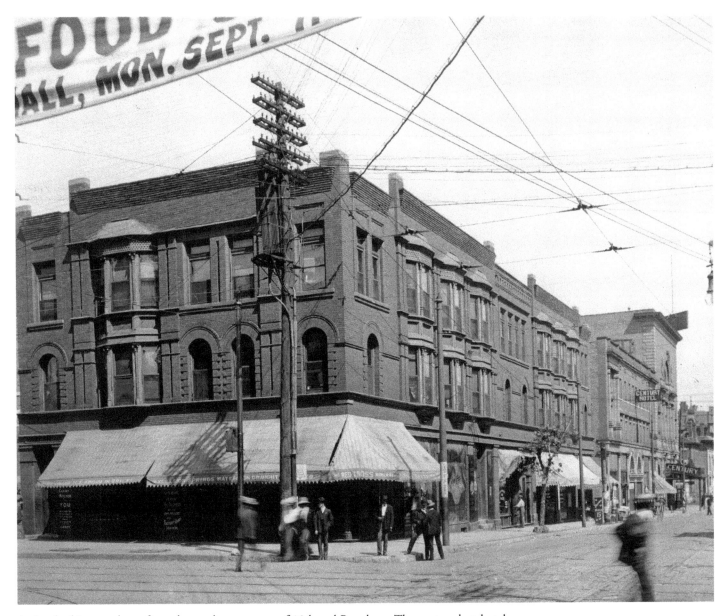

A view looking northeast from the southwest corner of 12th and Broadway. The century hotel and theater are also in this 1900 photograph.

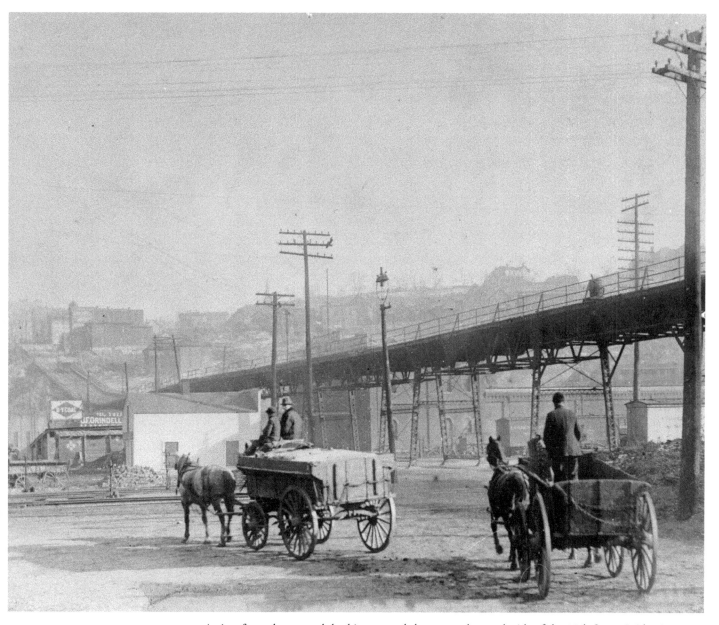

A view from the ground, looking toward the east at the north side of the 12th Street Bridge in 1900. In its early days, the 12th Street Bridge was made of iron. In 1903, a flood swept it away as well as 15 other Wyandotte County bridges. The 12th Street Bridge was soon repaired for $75,000.

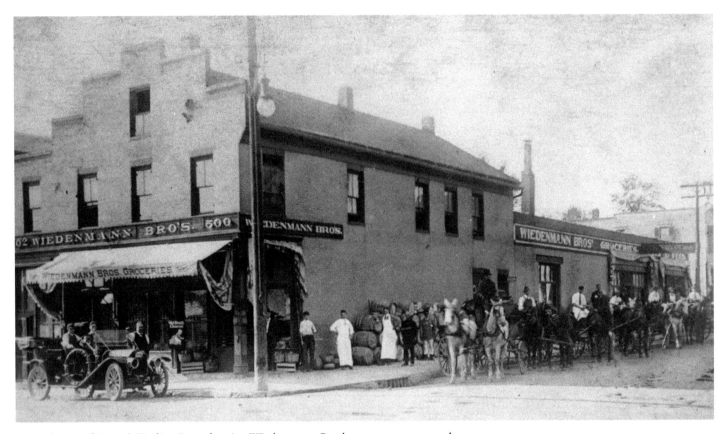

A 1904 view of Boone's Trading Post, showing Wiedenmann Brothers grocery store as the occupant of the building. Albert Boone, grandson of Daniel Boone, started operation of the trading post in Westport in 1850.

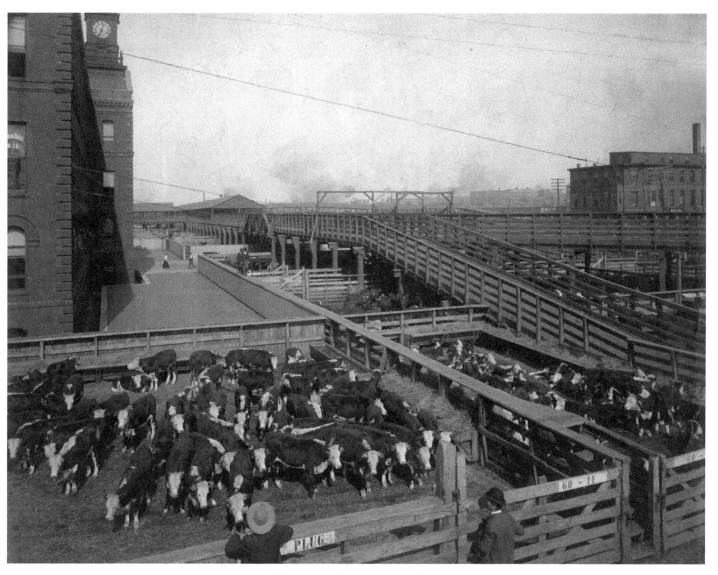

A portion of the Livestock Exchange building is seen in this 1900 photograph of a few men peering into the cattle pens. The stock runway is also visible in the background.

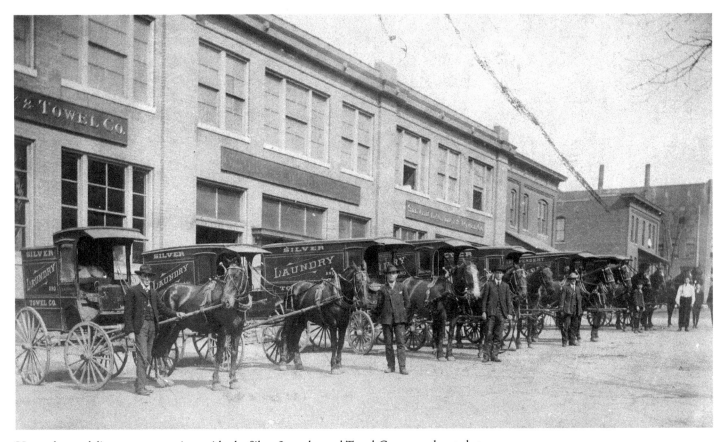

Horse-drawn delivery wagons wait outside the Silver Laundry and Towel Company, located at 1012–1020 Campbell Street.

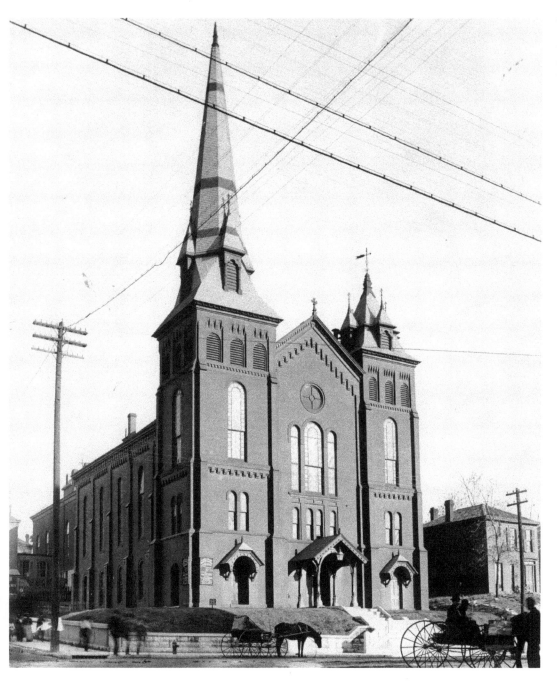

The Grand Avenue Methodist Church, located on the southeast corner of Ninth and Grand Avenue.

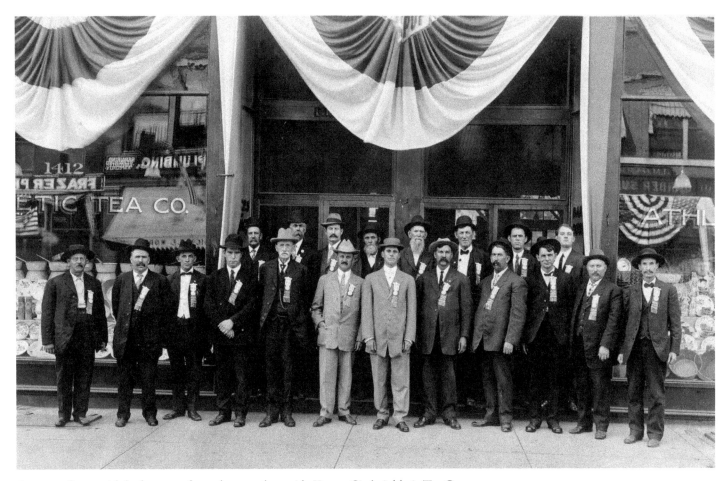

A group of men with badges pose for a photograph outside Kansas City's Athletic Tea Company on Main Street, circa early 1900s.

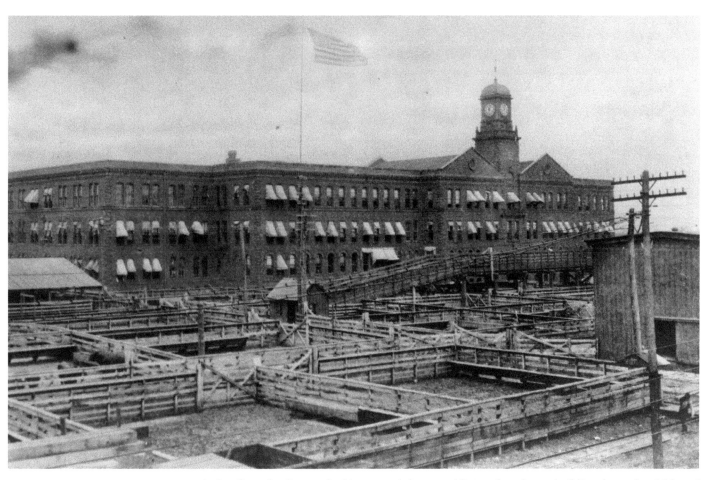

A view from the distance looking toward the second livestock exchange building, located at 16th and Genesee, in 1900. The first livestock exchange building was only 24 square feet when it opened in 1871.

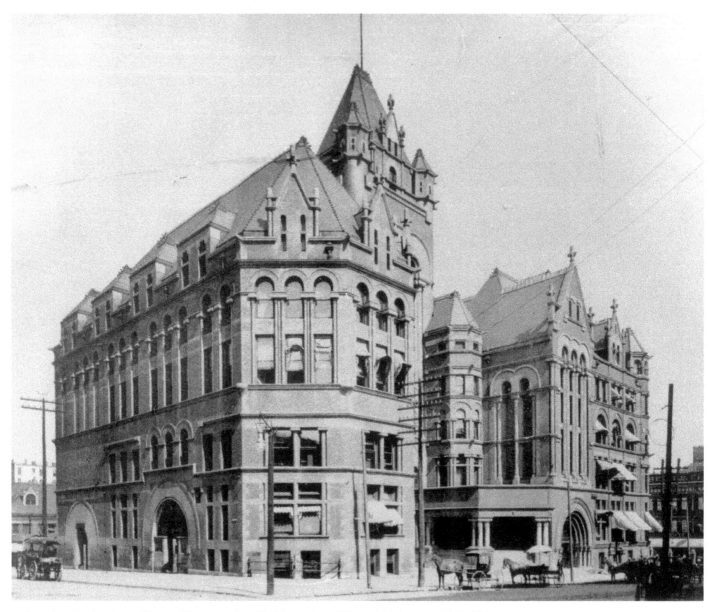

A frontal and side view of Kansas City's first City Hall located at Fifth and Main, circa 1900. This building was erected in 1892 after a $300,000 bond issue passed to build a new City Hall.

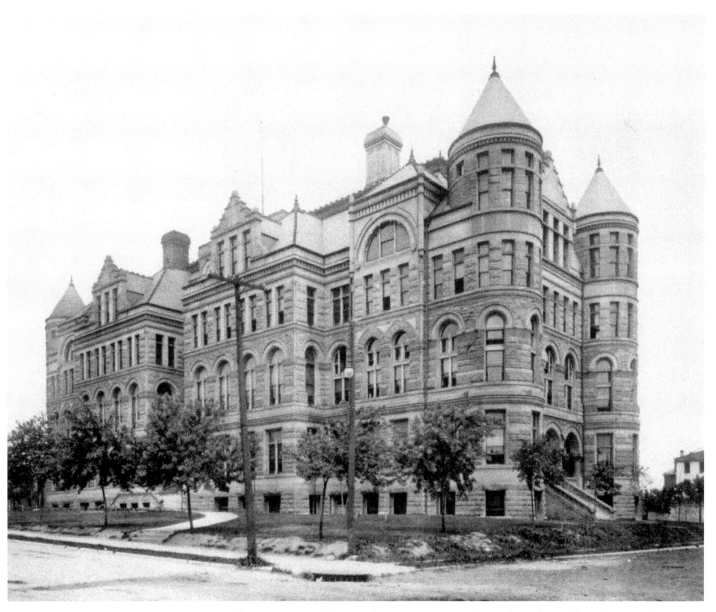

An early 1900s view of the second Kansas City Courthouse, located at Fifth and Oak, built in 1892.

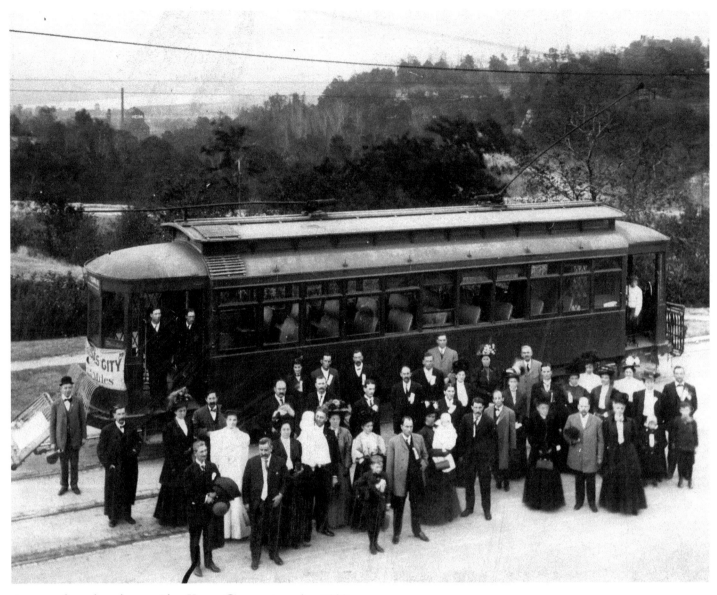

A group of people gather outside a Kansas City streetcar, circa 1900.

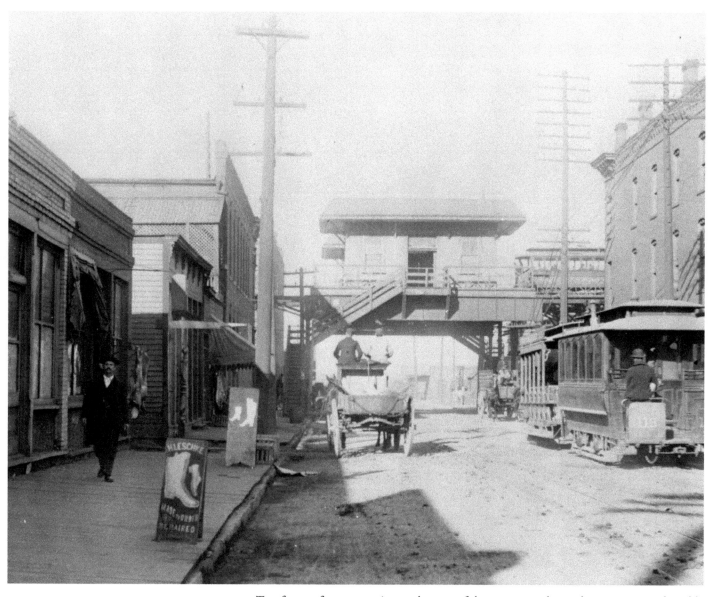

Two forms of transportation at the turn of the century—a horse-drawn wagon and a cable car—traveling near Ninth and Mulberry in West Bottoms. The elevated line for Ninth Street is in the background.

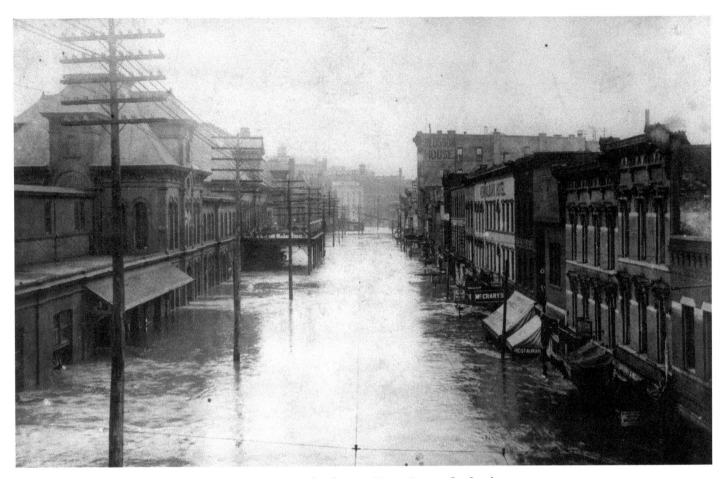

A view along the flooded Union Avenue in West Bottoms, also showing Union Depot. On Sunday morning, May 31, 1903, one of Kansas City's most disastrous floods struck when the valleys of the Kansas, or Kaw, and Missouri rivers flooded. The flood swept away many bridges and isolated Kansas City from outside communication.

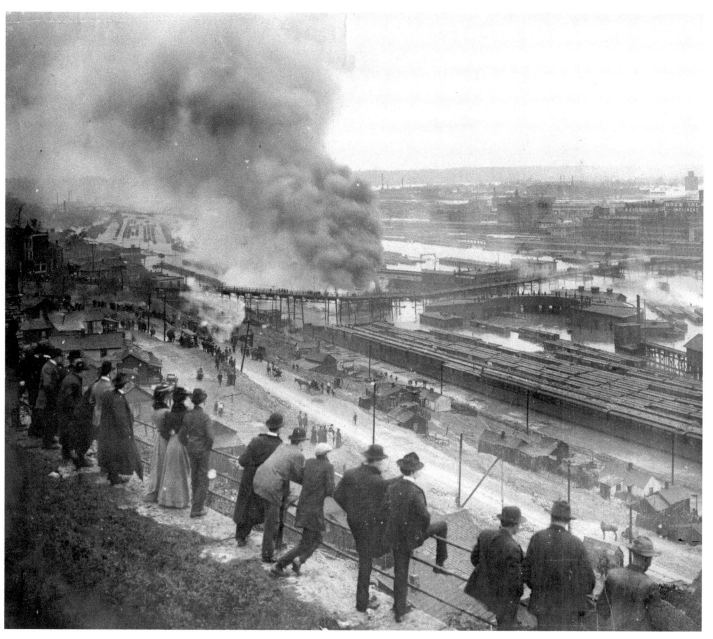

A crowd gathers to watch a fire near the 12th Street Bridge in West Bottoms in 1903. The railroad yards are shown flooded.

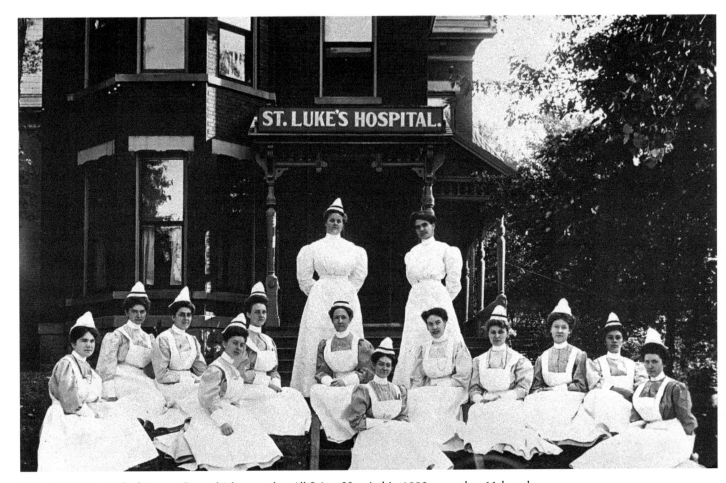

Saint Luke's Hospital of Kansas City, which opened as All Saints Hospital in 1882, moved to 11th and Euclid in 1906. The former home of Samuel Scott, the remodeled building was purchased by hospital founder Dr. Herman Pearse for $15,000 and sold to Saint Luke's for $1. It would remain the hospital's home for the next 17 years.

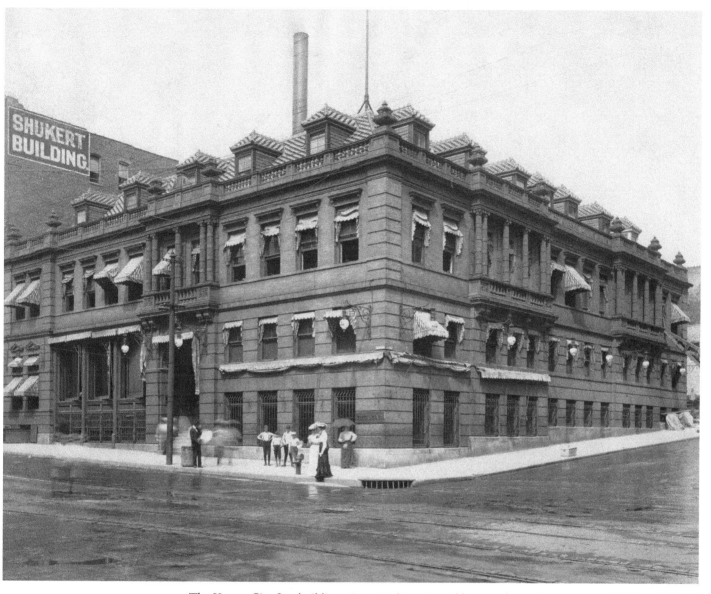

The Kansas City Star building, circa 1904, is pictured here on the northeast corner of 11th and Grand Avenue.

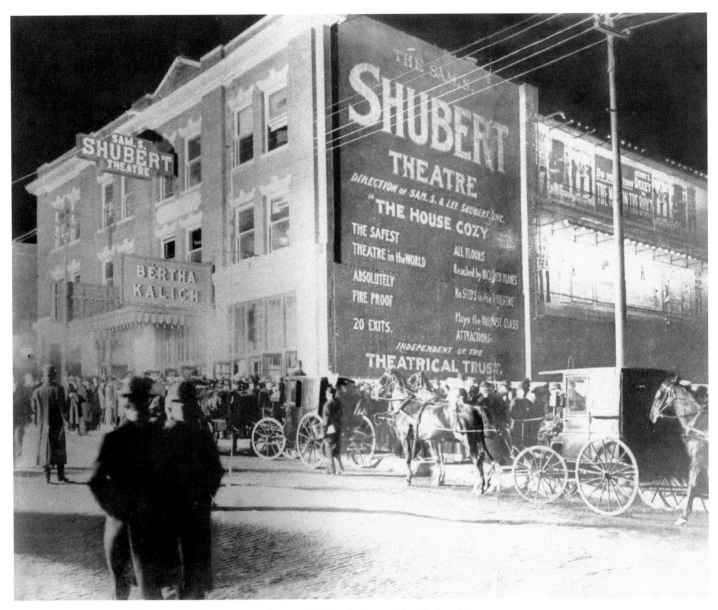

A 1907 evening view of the Shubert Theater located at 104 W. Tenth Street. The Shubert Theater was built for $131,000 and opened on October 1, 1906.

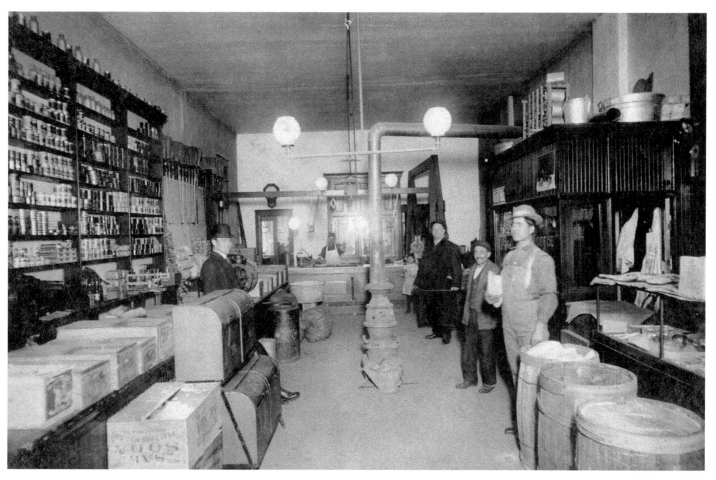

Mr. Aleshi poses behind the counter of his store in Kansas City, Missouri, on Holmes Street in 1908.

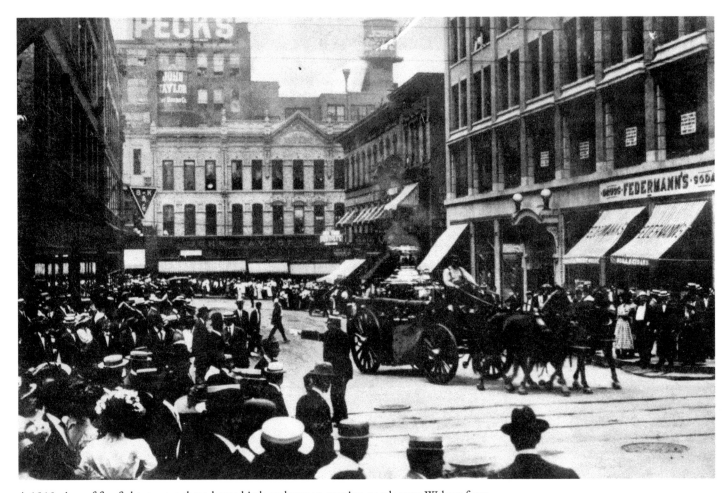

A 1910 view of fire fighters on a three-horse hitch and wagon turning north onto Walnut from Petticoat Lane. Peck's building stands in the background.

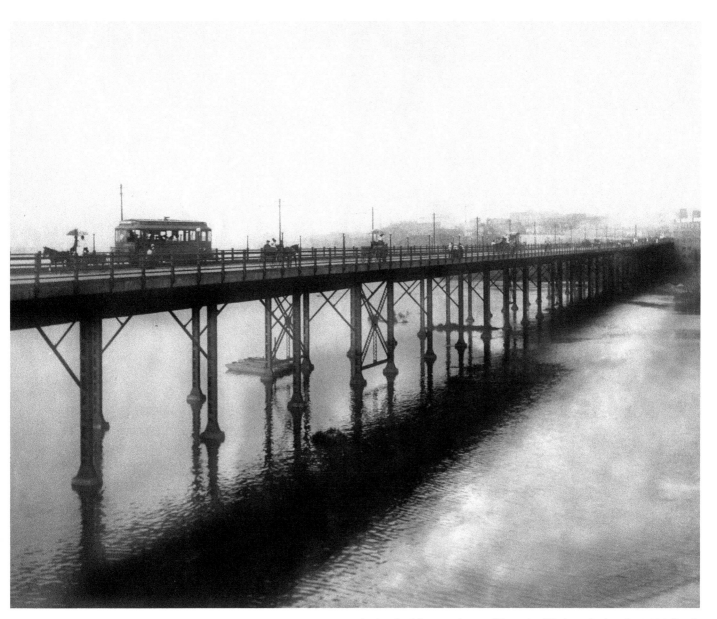

A view looking northeast of Intercity Viaduct during the 1908 flood.

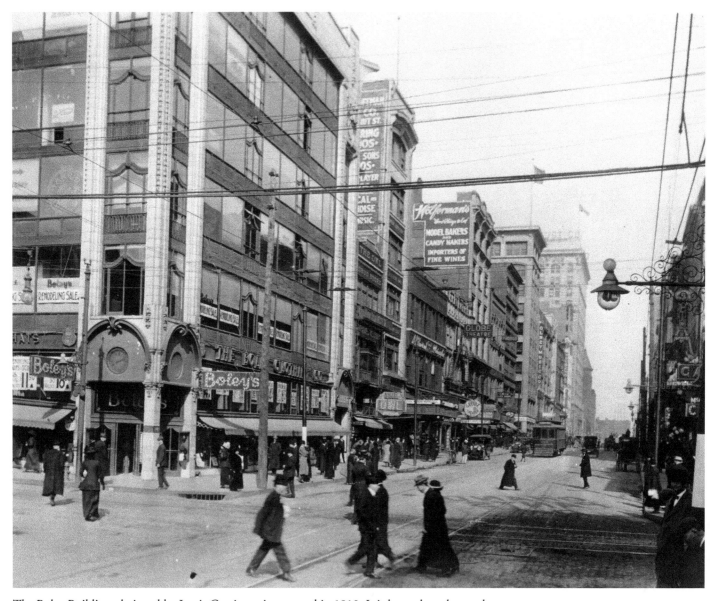

The Boley Building, designed by Louis Curtiss, as it appeared in 1910. It is located on the northwest corner of 12th and Walnut.

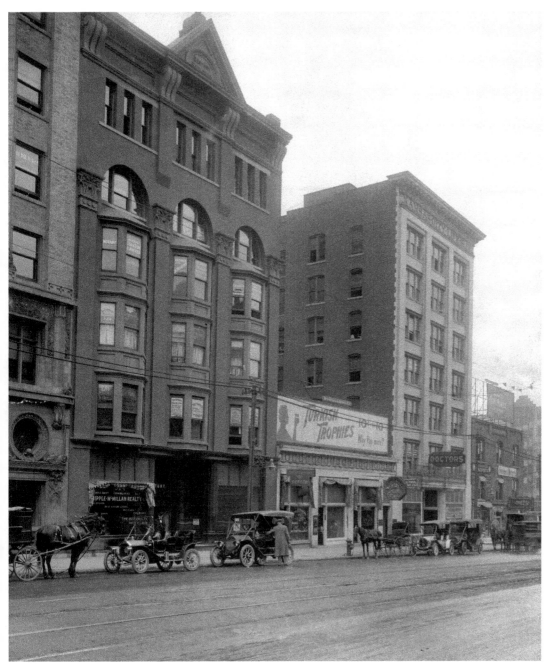

A view of many buildings along Eighth and Grand in 1910. The photograph offers a full view of the Century Building.

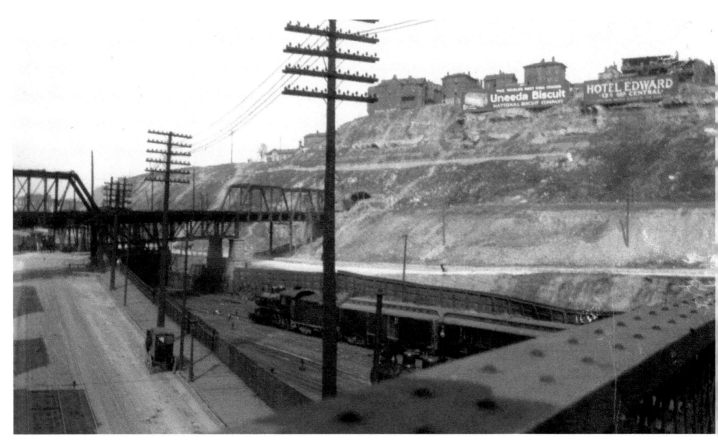

A view from the Union Depot area of the West Bluffs at Eighth Street and Eighth Street Tunnel in Kansas City, circa 1915. The multiple billboards on the bluffs read, "Uneeda Biscuit: National Biscuit Company: 5 cents" and "Hotel Edward: 12th and Central." The handwriting on the photograph reads "Old Depot—Goose Neck from Chute."

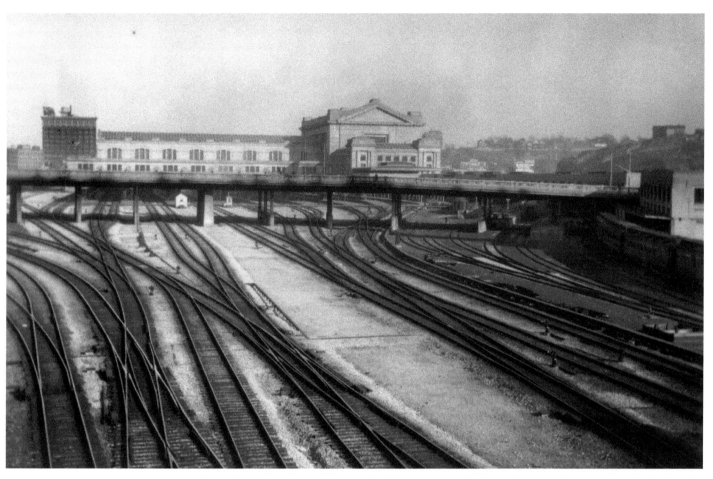

A view from Penn Street Viaduct of railroad tracks and Union Station as it appeared in 1915. Built in 1914, Union Station remains open today with restaurants, shopping, an Amtrak stop, a planetarium, and much more. The building is 850,000 square feet and originally featured 900 rooms.

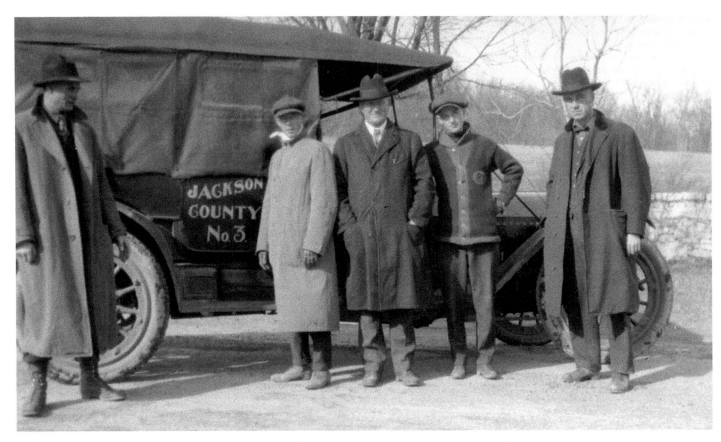

Five county highway engineers pose for a photograph in front of a Jackson County No. 3 car on Blue Avenue, January 24, 1916.

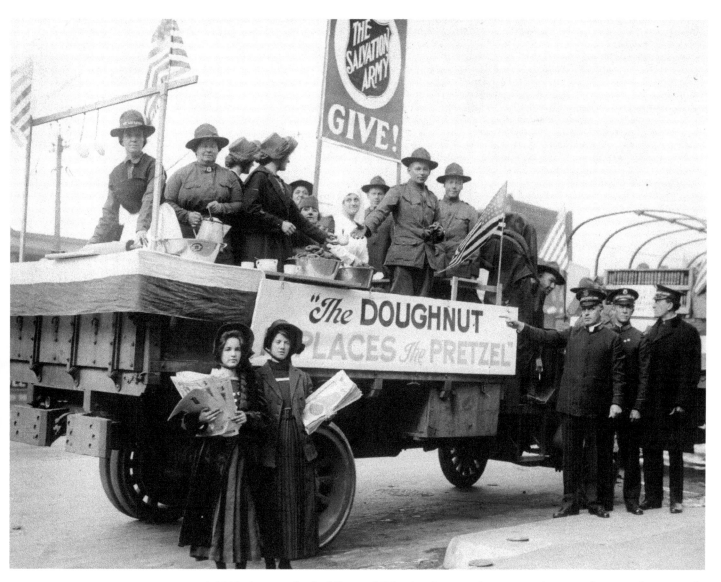

A 1918 photograph of soldiers and Salvation Army workers atop and surrounding a truck as part of a United War Work Drive.

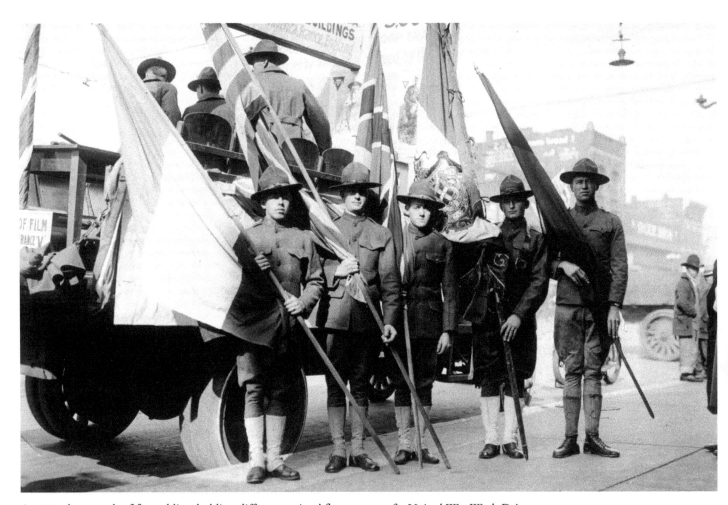

A 1918 photograph of five soldiers holding different nations' flags as part of a United War Work Drive in a World War I parade.

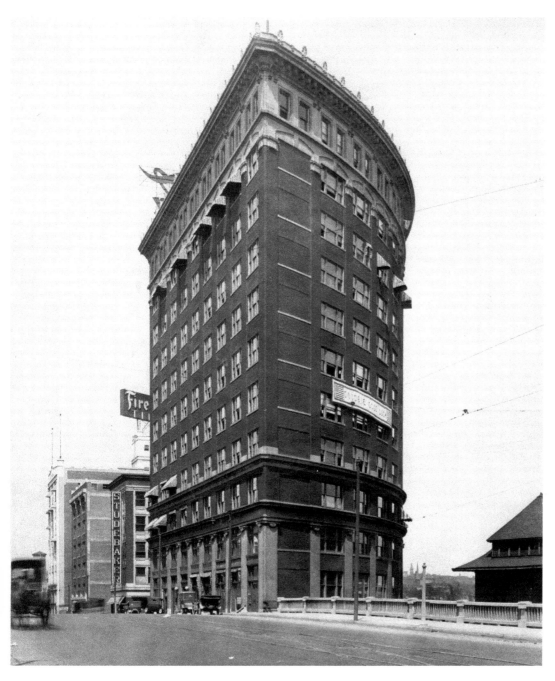

A photograph of the Coca-Cola building located at 21st and Grand Avenue, near Union Station. The building opened in 1915 and displayed a giant Coca-Cola sign on the storefront near the roof. By 1928, the sign came down. The tail end of the sign is seen atop the roof on the back side of the building in this image.

The first Bryant building, pictured here, is located at 11th and Grand Avenue. The first building was remodeled in 1903, and a second Bryant building was built adjacent to the first building in 1930.

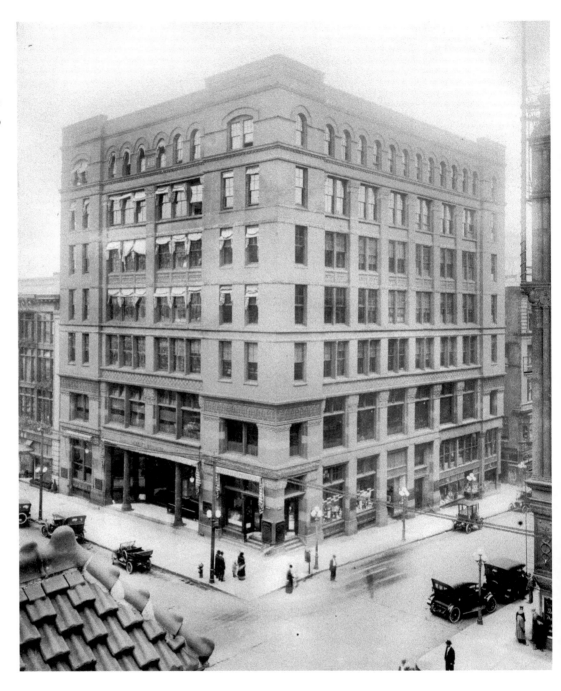

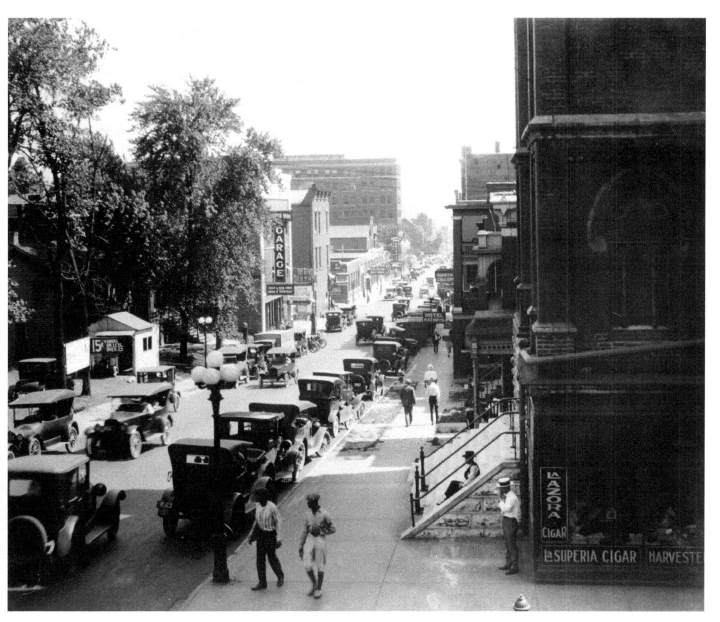

A view south along Oak from 11th Street, June 10, 1922.

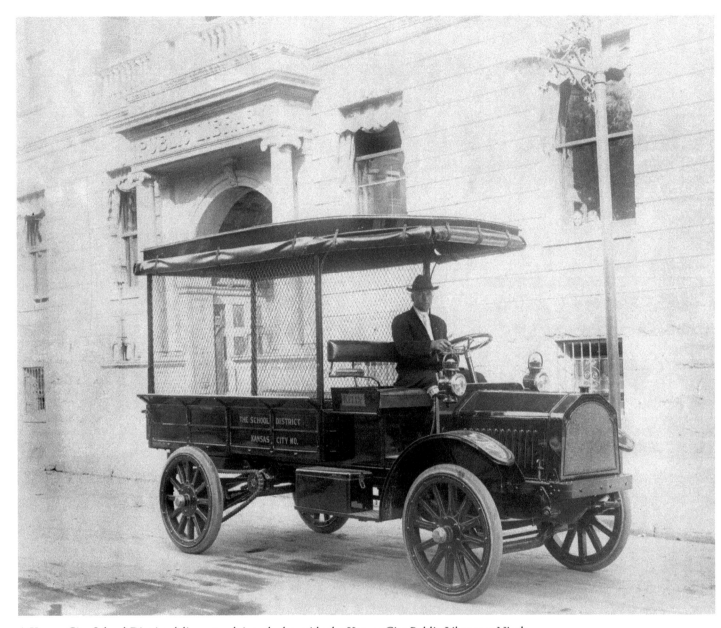

A Kansas City School District delivery truck is parked outside the Kansas City Public Library at Ninth and Locust.

From Cowtown to the Metropolis of the Southwest

(1920–1939)

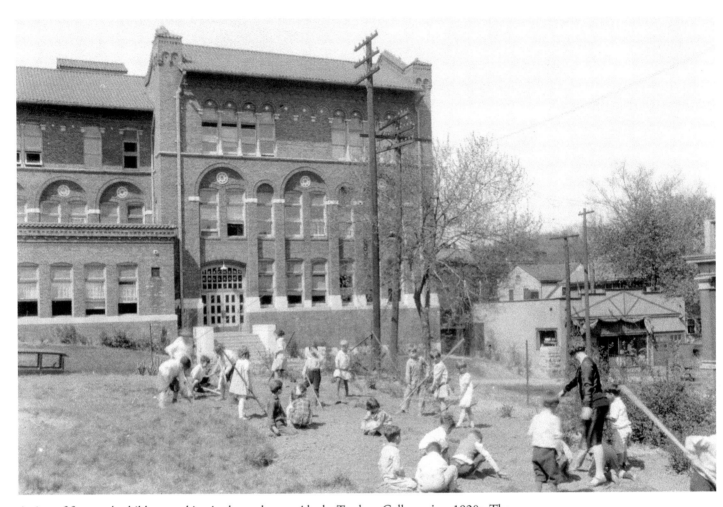

A view of first-grade children working in the garden outside the Teachers College, circa 1920s. The Teachers College was an outgrowth of a teacher-training department established in 1911 at Central High School. By 1931, the school offered a four-year program for training teachers.

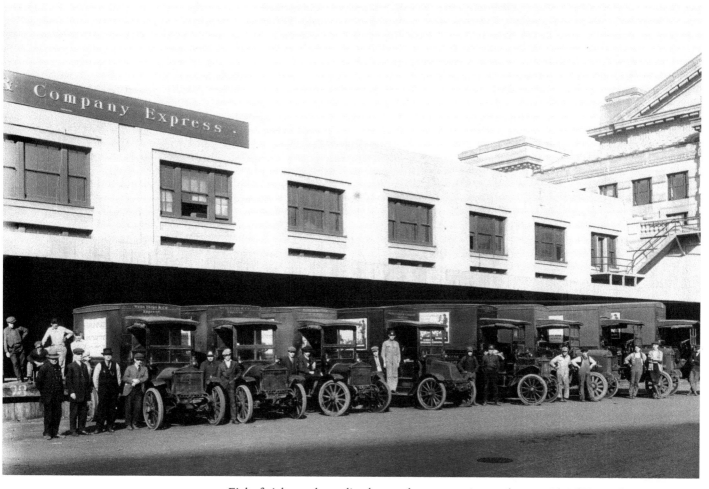

Eight freight trucks are lined up at the express wing on the west side of Union Station in 1920.

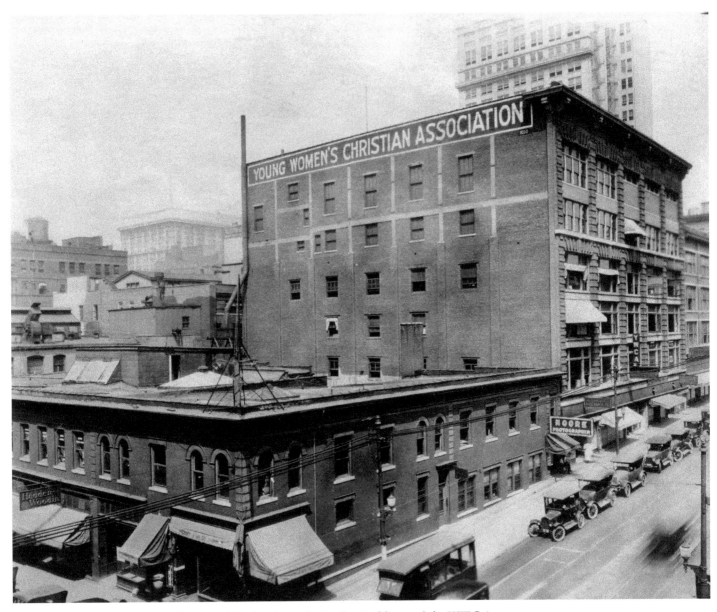

A view of the northwest corner of 11th and McGee shows the Brailey Building and the Y.W.C.A. Building in 1922.

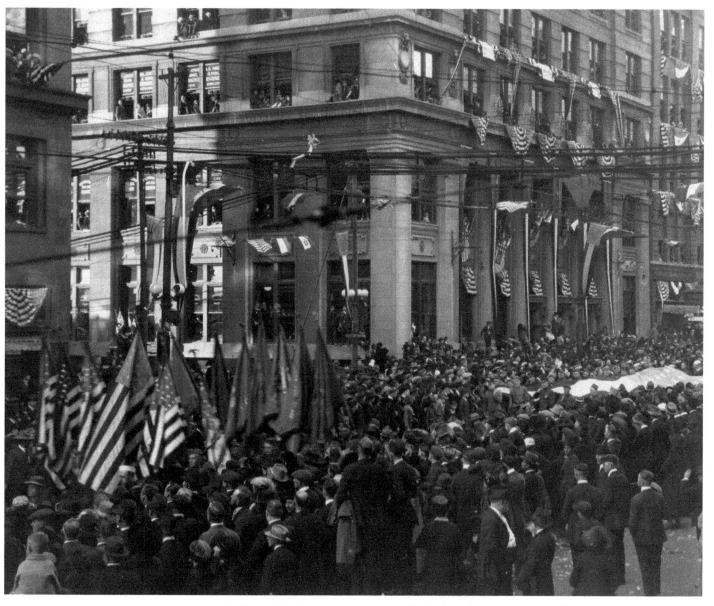

A view of the American Legion parade for the Liberty Memorial dedication at Tenth and Grand Avenue, November 1, 1921. R. A. Long and J. C. Nichols led a campaign to raise $2 million after Kansas City citizens called for a monument for war heroes in 1918.

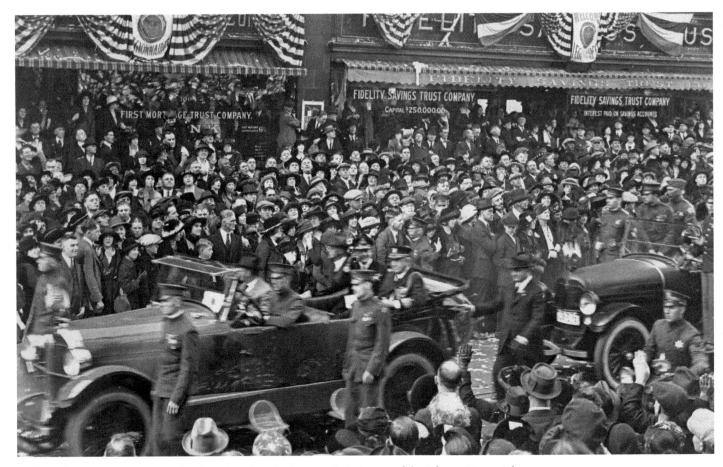

A November 1, 1921, photograph of the American Legion parade in honor of the Liberty Memorial dedication. The scene is on the southwest corner of 10th and Grand Avenue and the Fidelity Savings and Trust Company building is visible in the background.

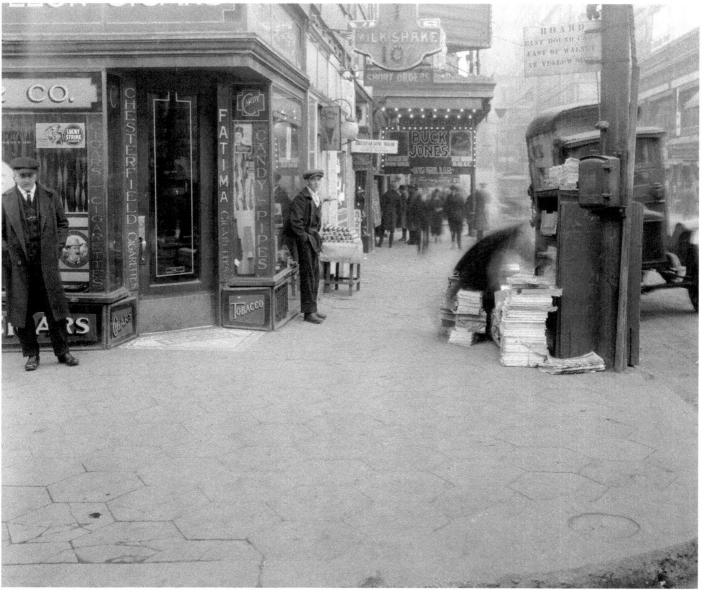

This view is to the west along the south side of 12th Street from Grand Avenue, March 23, 1924.

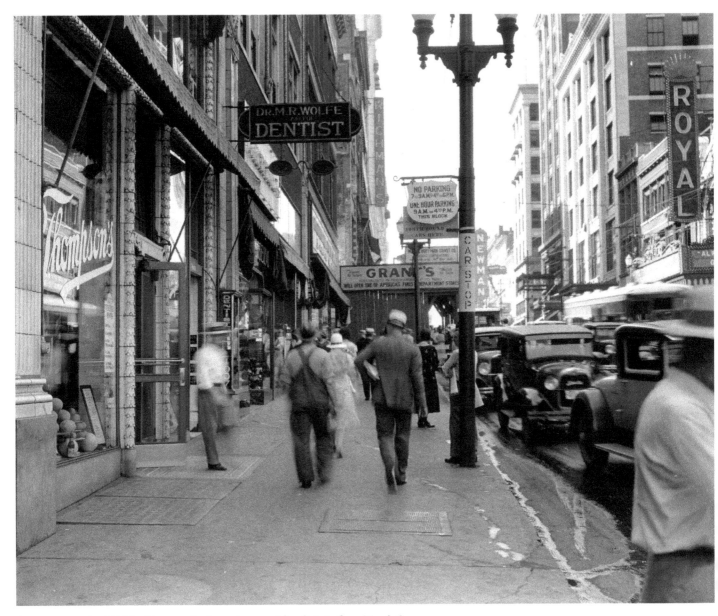

A street scene in 1925 looking north along the east side of Main from Tenth Street.

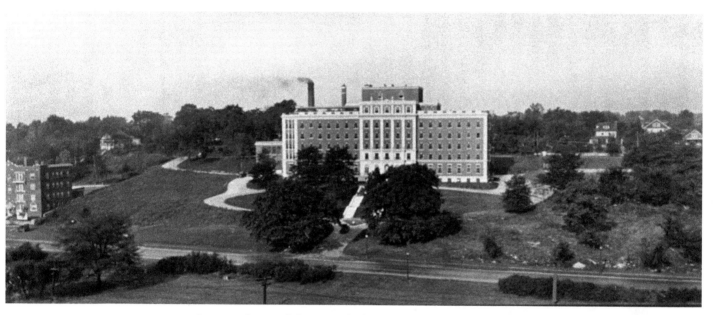

In 1923, Saint Luke's Hospital of Kansas City moved to its present location at 44th and Womall. The brick and terra-cotta structure was a state-of-the-art facility with 150 beds and featured such modern advances as electrically operated dumbwaiters and a solarium on each floor.

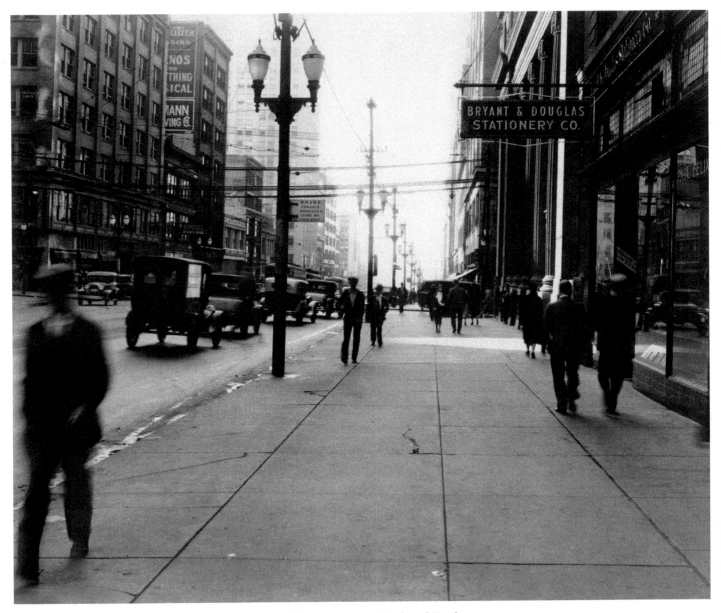

A 1925 street scene looking south along the west side of Grand, between Ninth and Tenth streets.

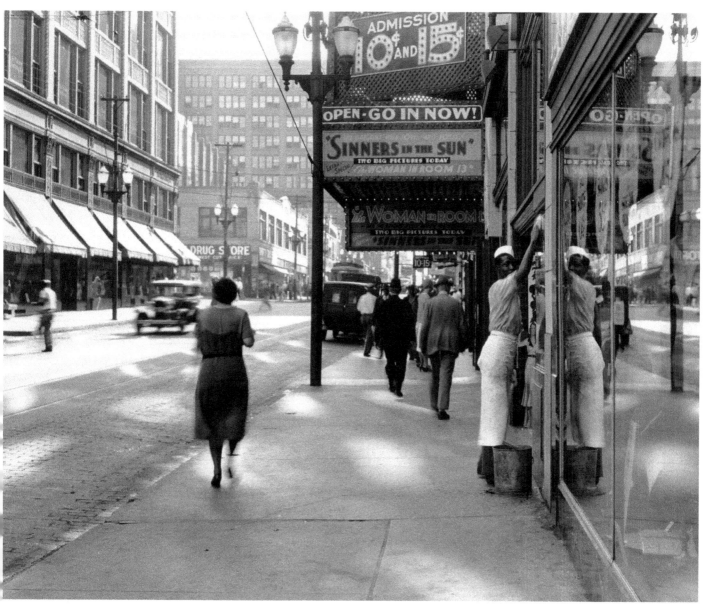

A street scene about 1932 on the south side of 12th Street, between Walnut and Grand. The Regent Theater is also pictured.

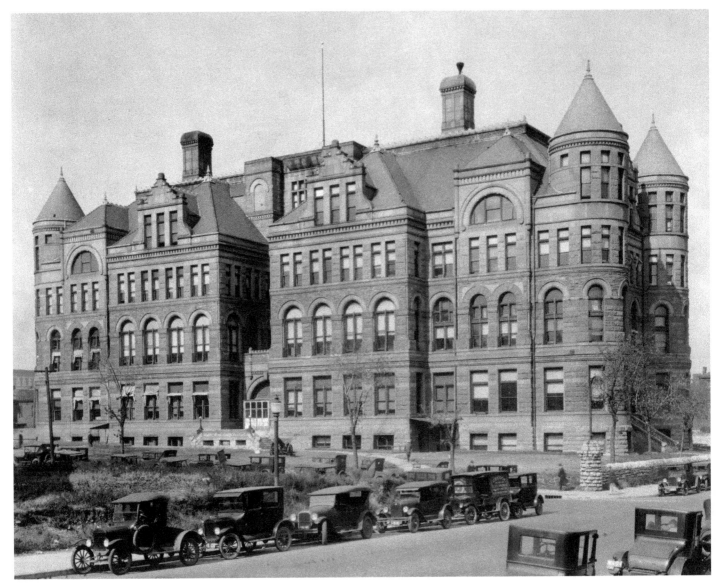

The second building of the Jackson County Courthouse as it appeared in 1925.

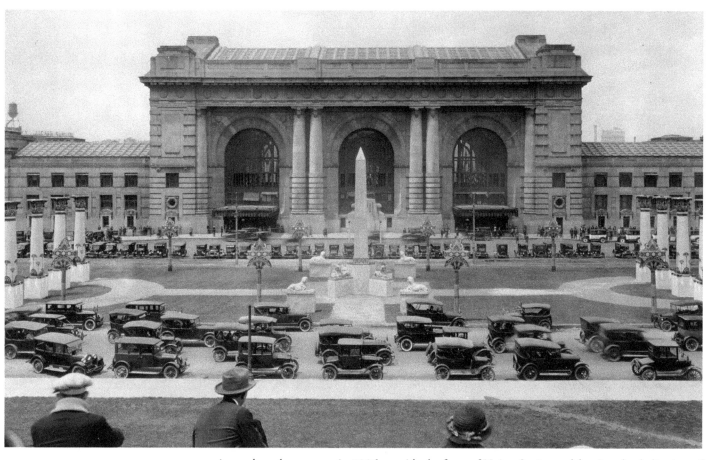

A parade and ceremony in 1926, outside the front of Union Station, celebrating the dedication of Ararat Temple.

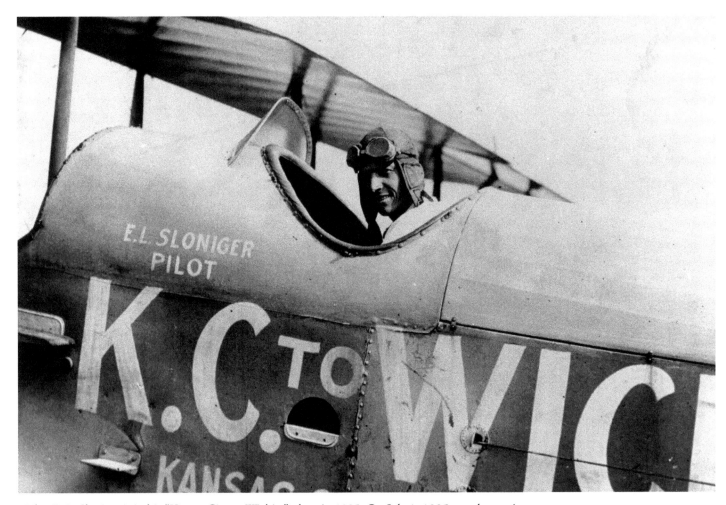

Pilot E. L. Sloniger is in his "Kansas City to Wichita" plane in 1925. On July 1, 1925, regular service between Kansas City and Wichita was inaugurated by the Kansas City Airways Transportation Company, by Mr. Sloniger.

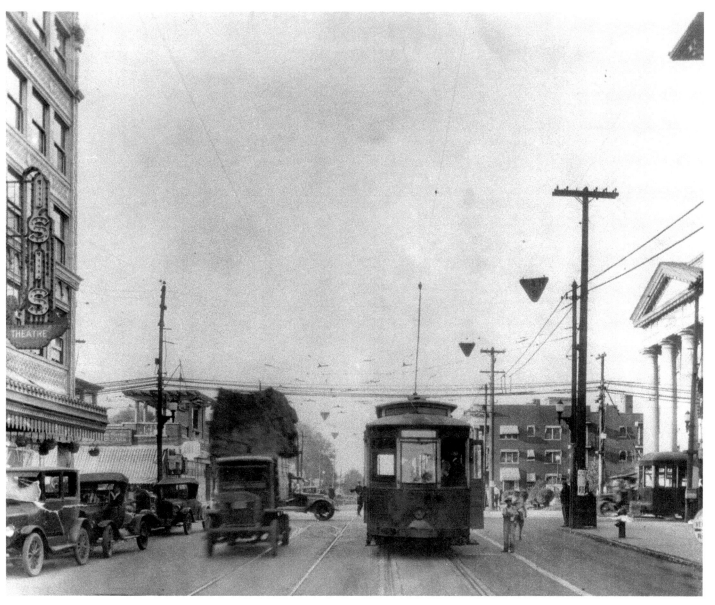

A northward view of 31st and Troost. The Isis Theater on the west side of the street was erected in August 1918 and was considered the finest "suburban" theater in the city. It closed in 1970, just two months after a riot took place outside the building.

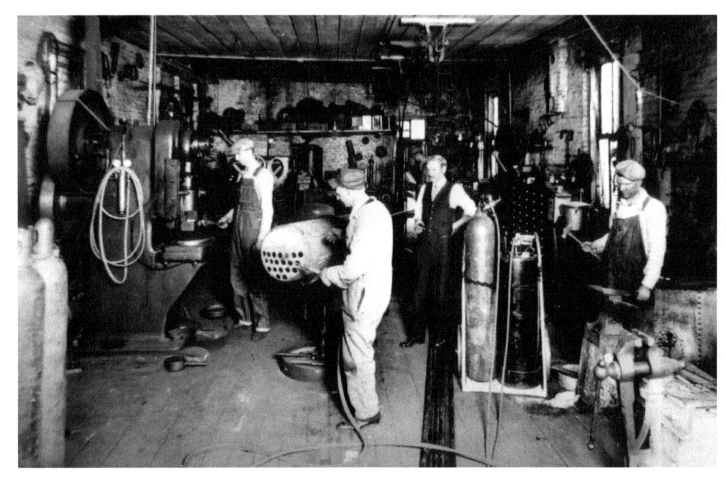

A 1927 photograph of Schertz Refrigeration Company in Kansas City.

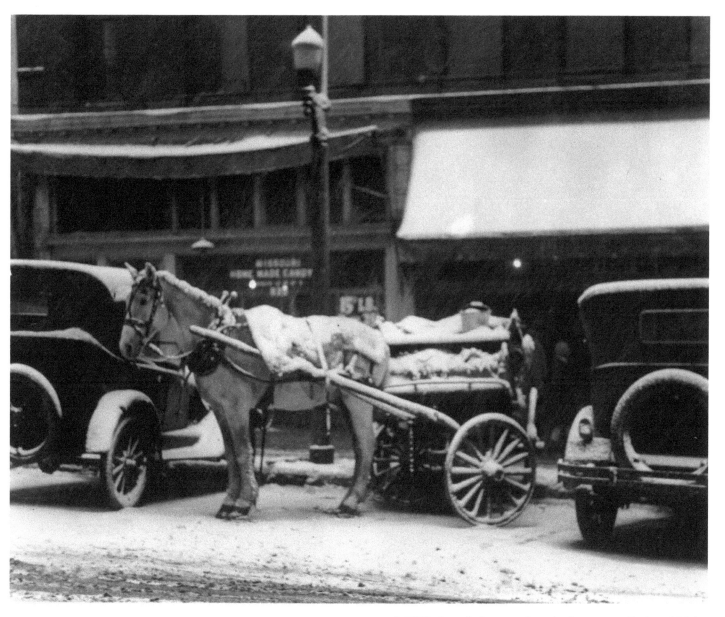

A 1928 view of a horse and cart in the snow at Sixth and Main.

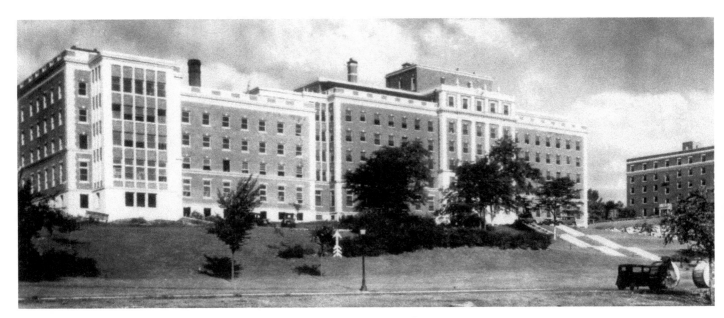

In 1928 a south wing with another 100 beds was added to Saint Luke's Hospital.

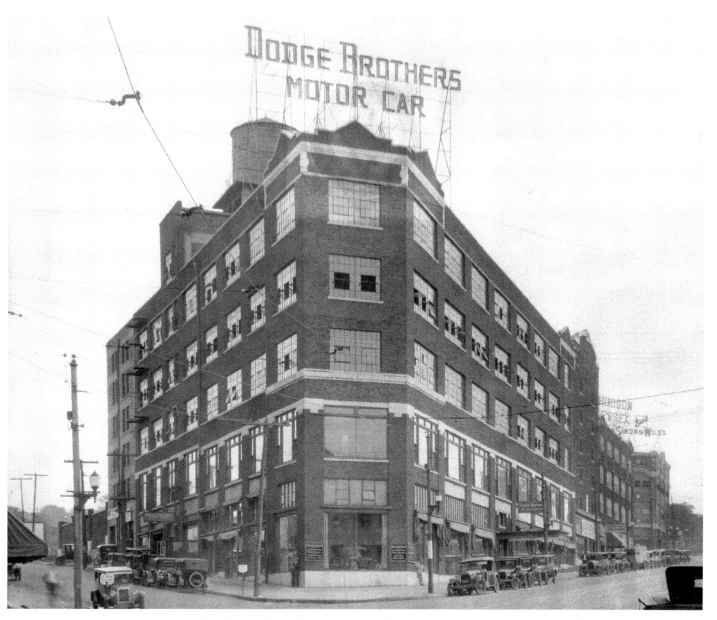

The Butler Motor Company is in full view in this photograph, circa 1928. The sign atop the building reads, "Dodge Brothers Motor Car." The building was located on 26th Street between Walnut and Grand Avenue. Farther down the street, signs advertise Auburn, Hudson, Essex, Simons-Wiles, and Buick.

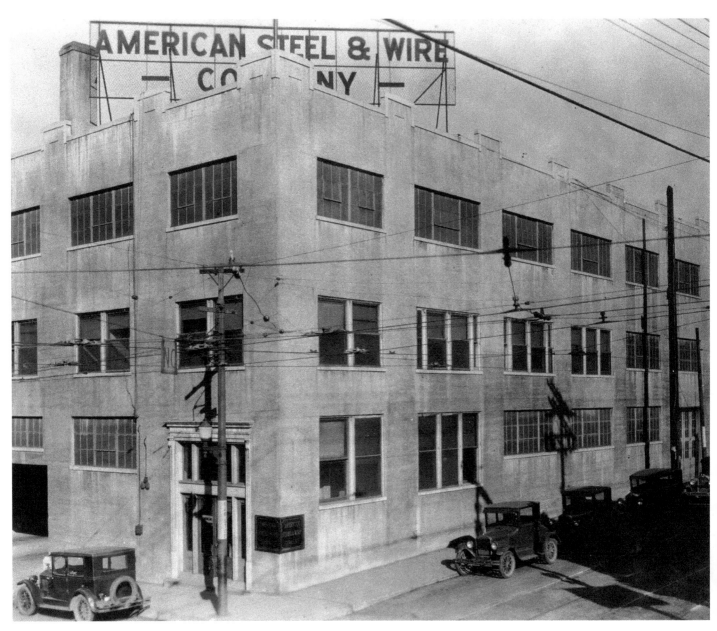

A view of the American Steel and Wire Company located at 417-23 Grand Avenue, circa 1928.

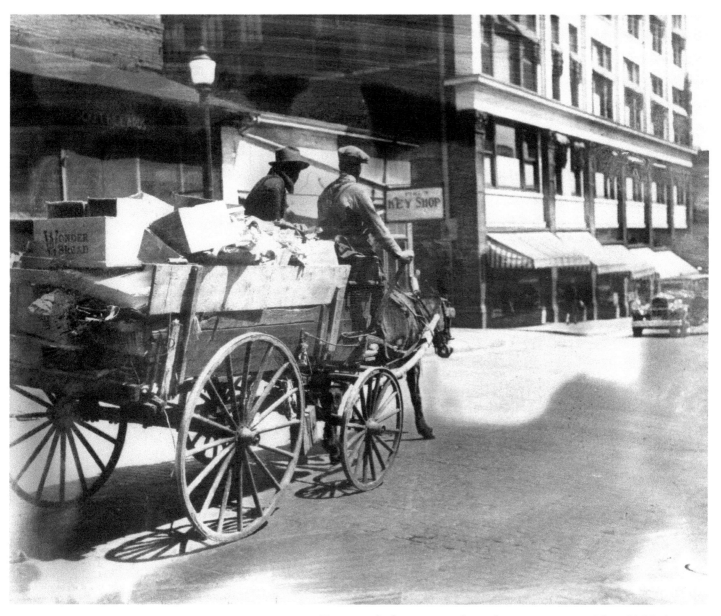

Two men ply the street on a horse-drawn wagon near 13th and Main in 1929.

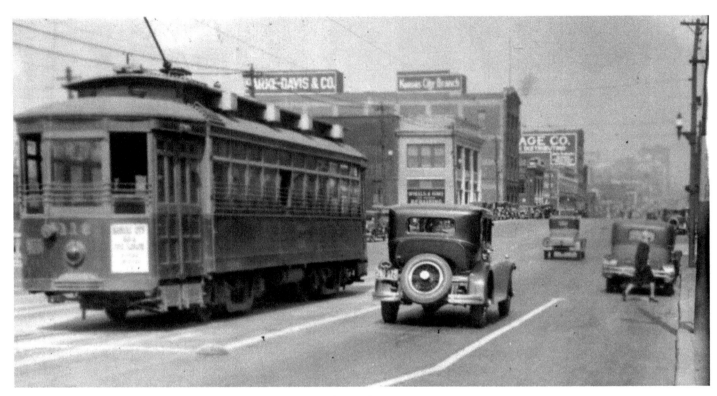

A 1929 photograph of a streetcar and automobiles near 24th and Grand.

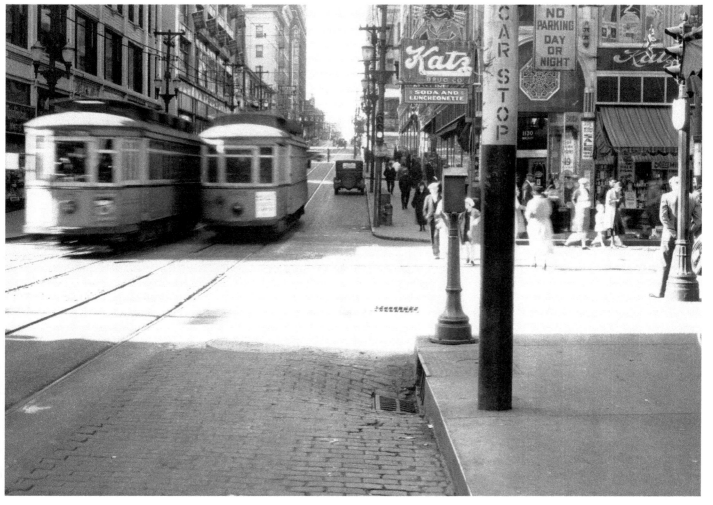

The Katz Drugstore sign hangs above streetcars near 12th and Walnut in 1930.

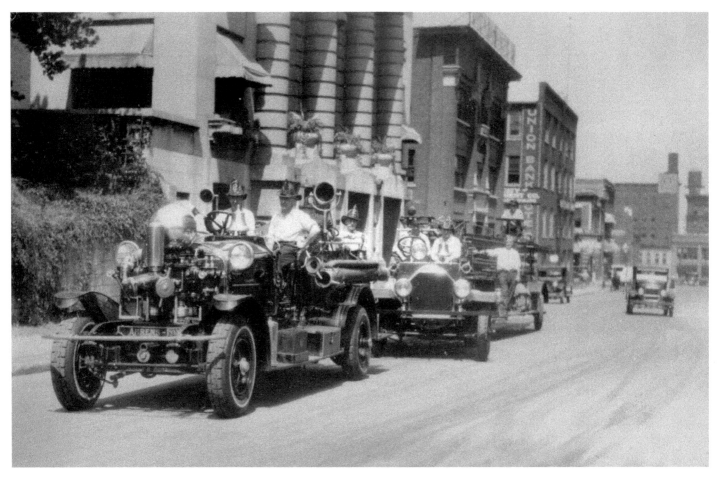

A group of fire trucks in front of department headquarters, Central Fire Station, located at 11th and Central in 1930.

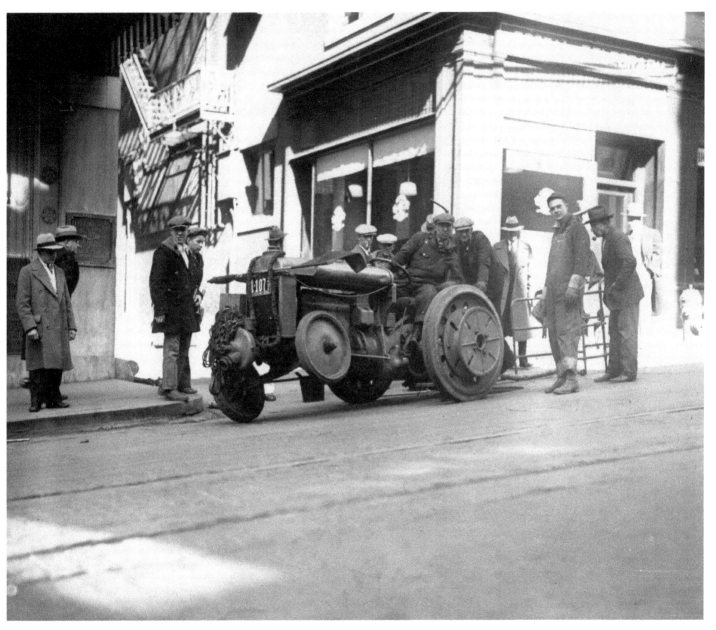

A Kansas City street scene in the 1000 block of Walnut shows a street crew using a tractor, February 10, 1930.

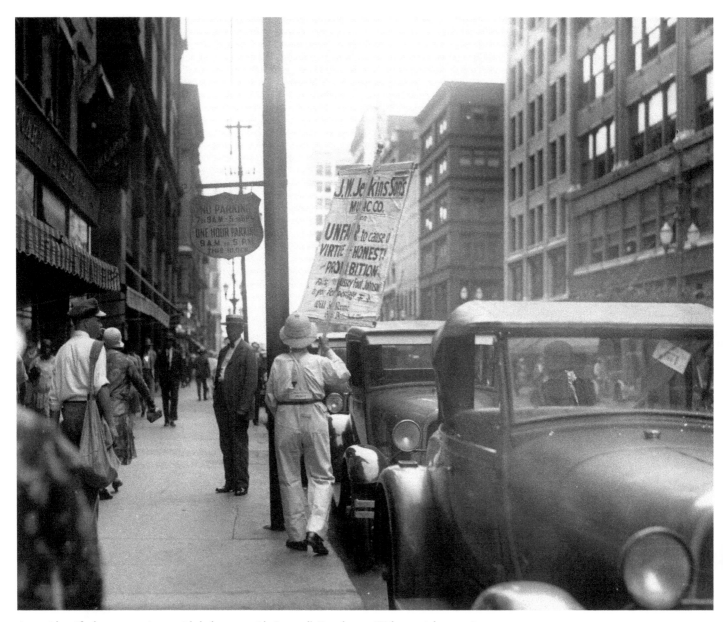

An unidentified man wearing a pith helmet outside Jaccard's Jewelry on Walnut, pickets against Jenkins Music Company in 1930.

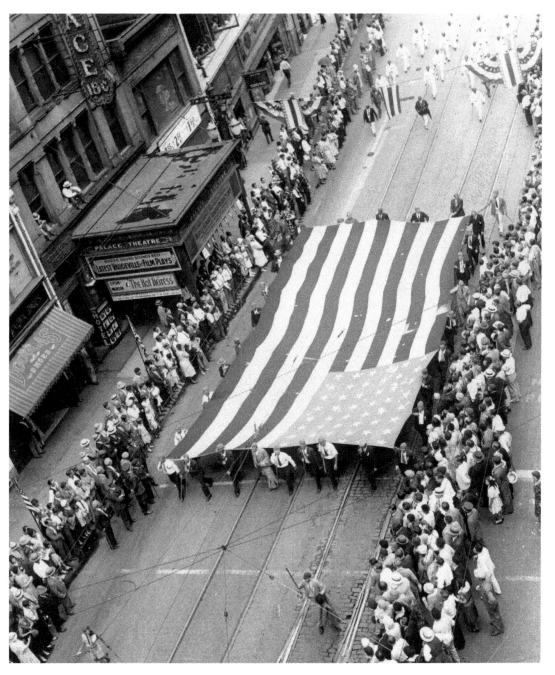

Men marching southward along Main Street outside the Palace Theater carry an oversized Stars and Stripes flag in 1930.

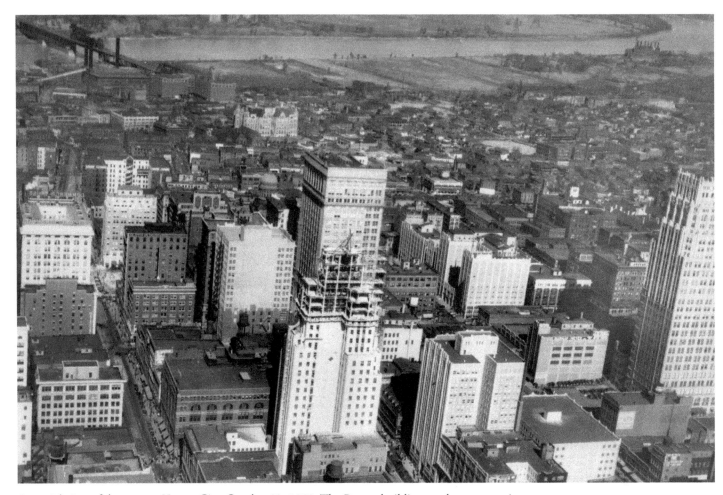

An aerial view of downtown Kansas City, October 30, 1930. The Bryant building, under construction, and the Missouri riverfront area are also in view.

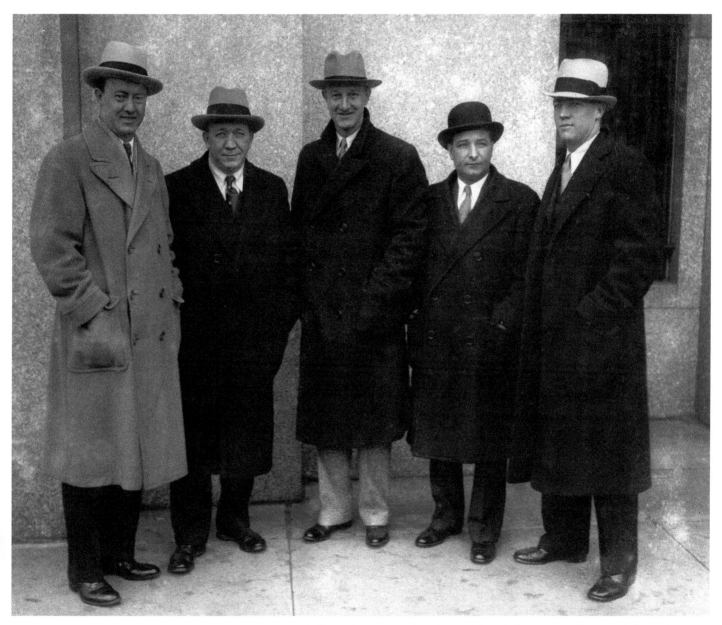

Notre Dame football coach Knute Rockne (second from left) is pictured here with four other men outside Union Station, March 31, 1931. This is believed to be the last picture ever taken of Rockne, who was killed in a plane crash outside Bazaar, Kansas, on the same day.

A full view of the Russell Stover Candy store, circa 1931, located at 1120 E. Linwood. The store went by "Mrs. Stover's Bungalow" when Russell and his wife, Clara Stover, moved from Denver to Kansas City. Eventually, it was renamed Russell Stover's.

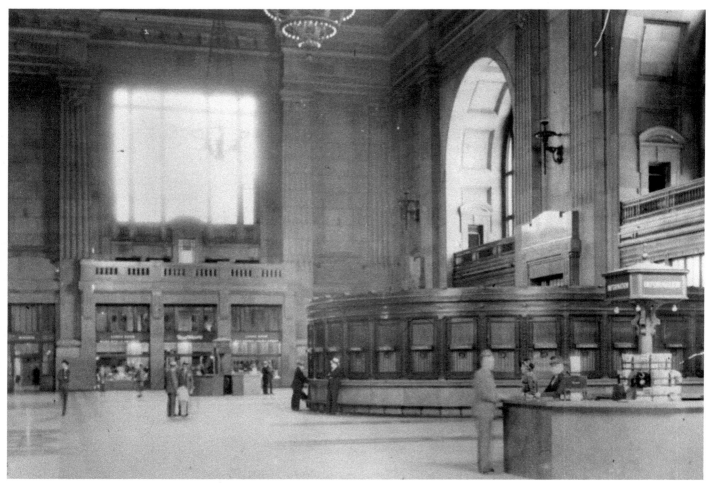

A view of the lobby and ticket counter inside Union Station in 1935.

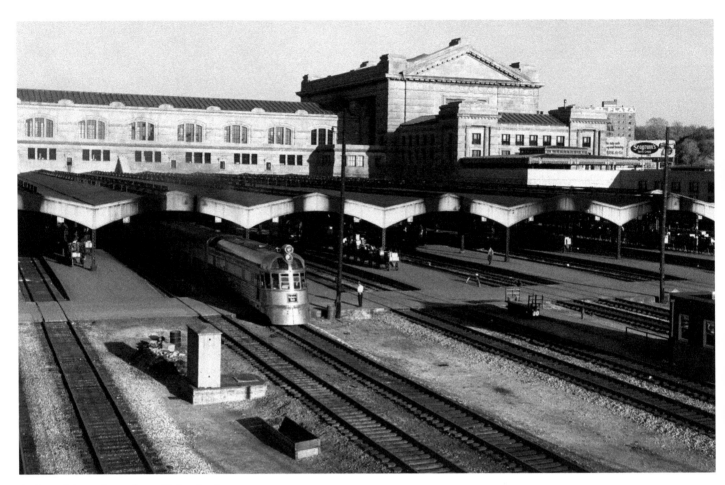

A view of the train tracks at Union Station.

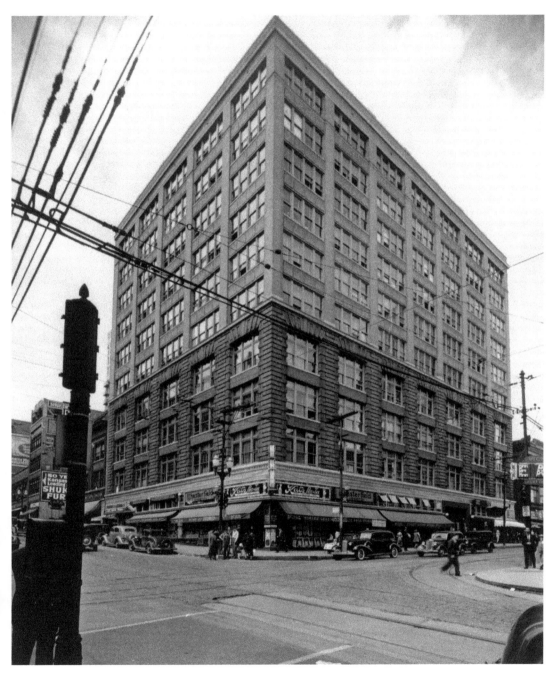

The Argyle building as it appeared in 1935 at 12th and McGee. Katz Drugstore was the first-floor tenant.

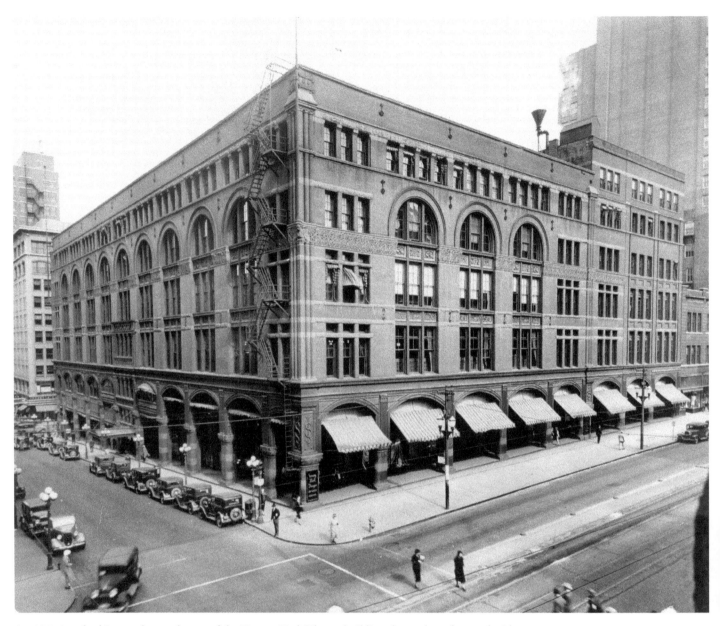

A 1935 view, looking to the northeast, of the Emery, Bird, Thayer building, located on the north side of 11th Street between Walnut and Grand Avenue.

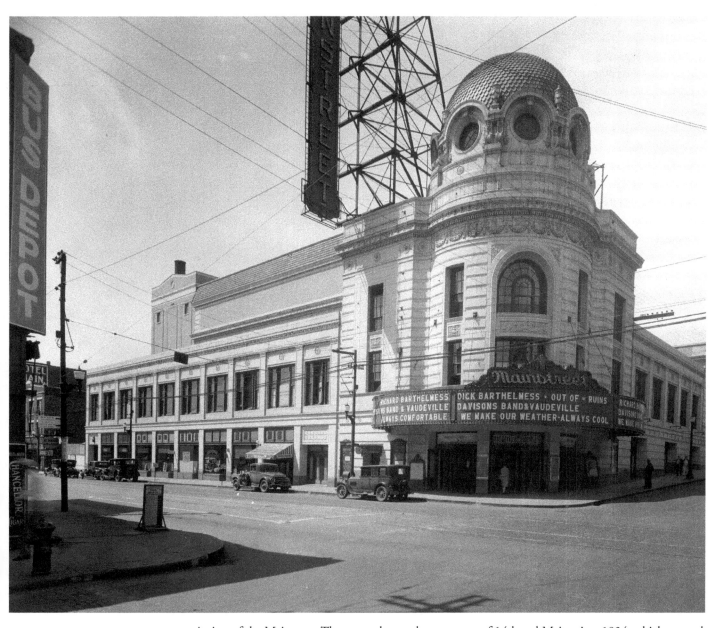

A view of the Mainstreet Theater at the southwest corner of 14th and Main, circa 1934, which opened on October 30, 1921. Its name was changed to the Missouri Theater in April 1941, and then to the Empire when it was sold to Stan Durwood.

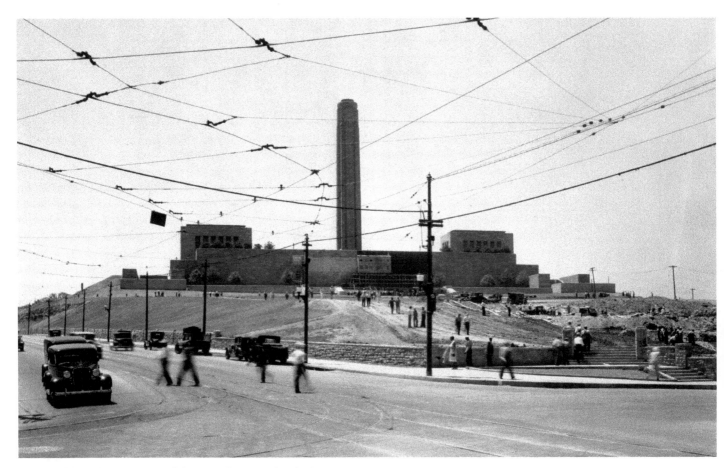

A view of the Liberty Memorial from Pershing Road, July 6, 1939.

WORLD WAR II TO THE MODERN ERA

(1940–1960s)

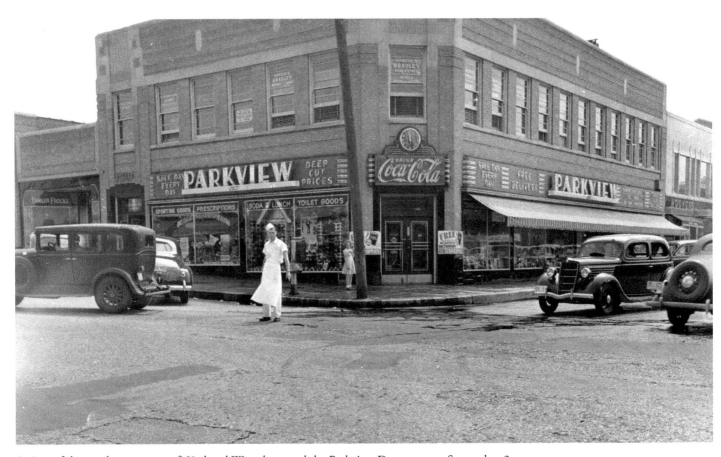

A view of the southeast corner of 63rd and Wyandotte and the Parkview Drugstore on September 2, 1940. This portion of Wyandotte later became known as the Brookside Plaza.

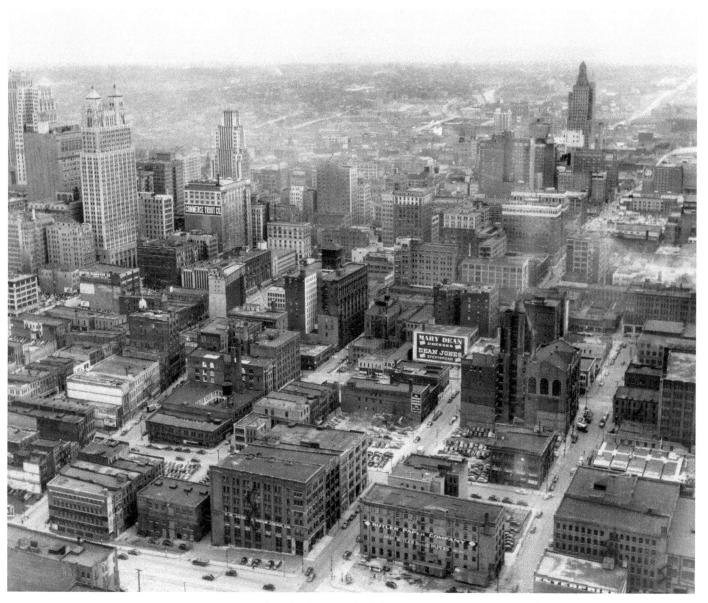

A 1940 photograph of downtown Kansas City near Sixth Street Trafficway and Central.

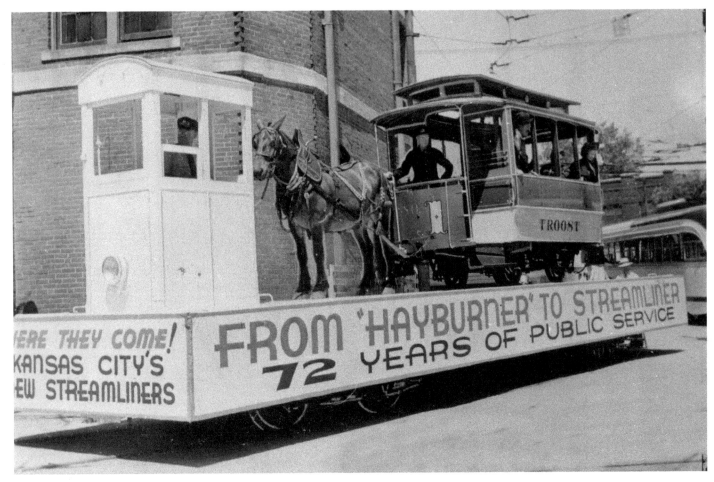

A mule-drawn Troost line car is being used to introduce the new streetcar in a parade on July 13, 1941.

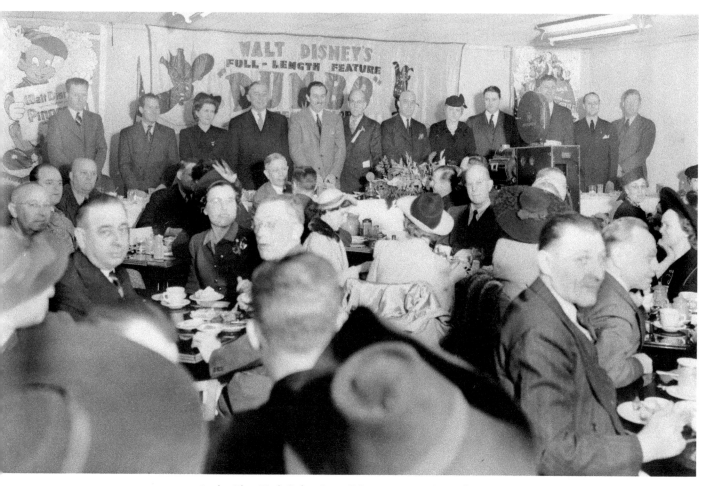

At the Blue Bird Cafeteria on February 13, 1942, Walt Disney and others pose at the head table of a luncheon put on by the South Central Business Association. Left to right are Homer L. Blackwell of the National Screen Service Corp.; Clarence Nash, the voice of Donald Duck; Mrs. Lillian Bounds Disney, Walt Disney's wife; Kansas City mayor John B. Gage; Walt Disney; SCBA president Edwin J. Barnes, Sr.; Frank S. Land, founder of the Grand Council of DeMolay; Mrs. Joseph C. Wirthman; Keith Martin, director of the Kansas City Art Institute; and three of Disney's classmates from Benton School—George L. Williams, Louis G. Lower, and Donald Monroe.

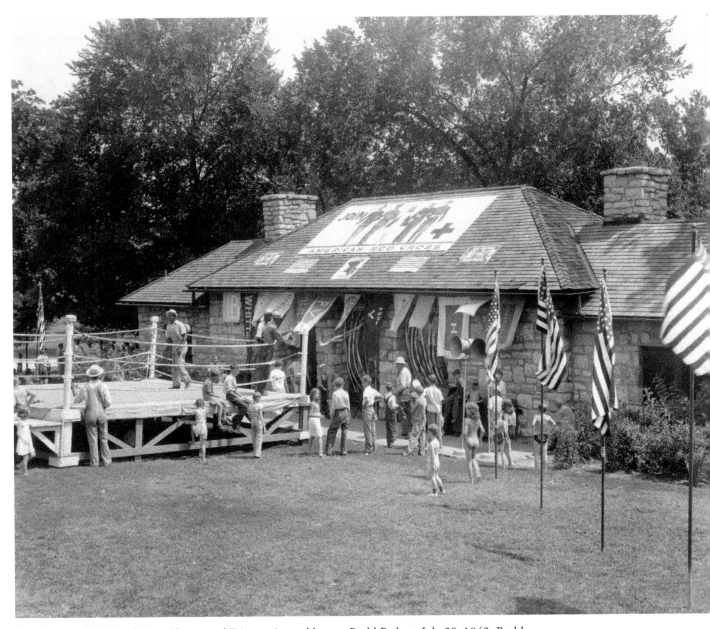

Participants of the North Area Playground Fair are pictured here at Budd Park on July 28, 1942. Budd Park was Kansas City's third park, acquired in 1892, 1901, and 1902. Azariah Budd gave the original 20 acres to the city in 1891.

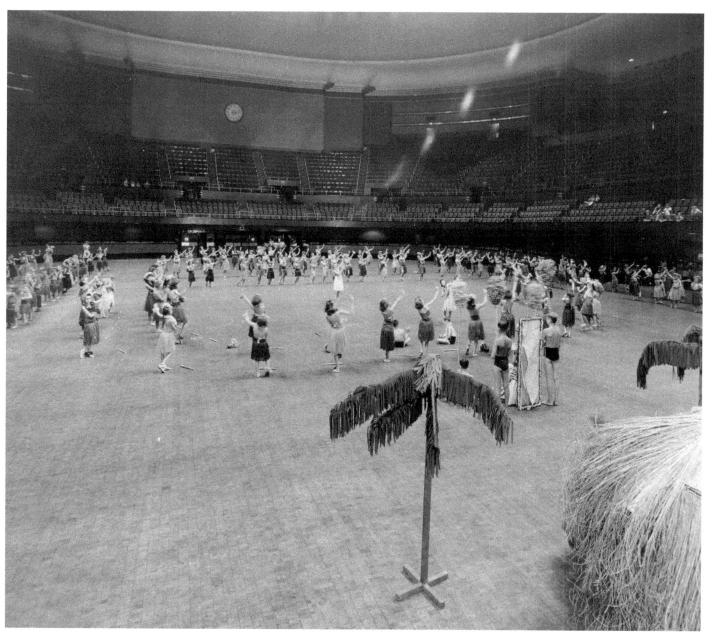

Costumed people participate in the "Hawaiian Dance" at the Summer Playground Festival held August 14, 1942, at Municipal Auditorium.

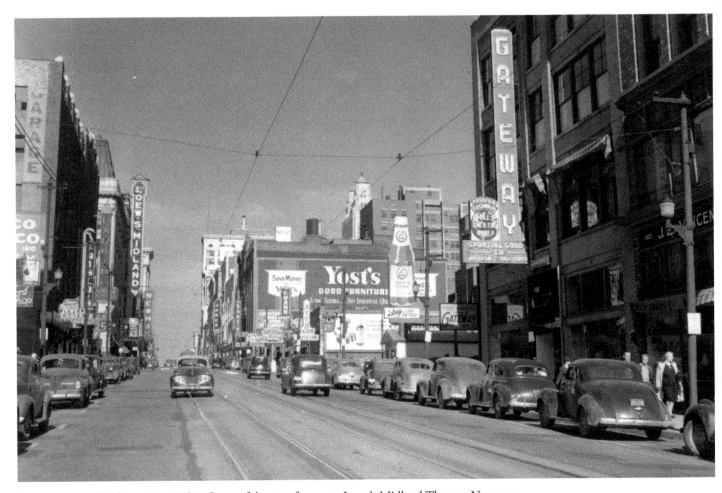

A street scene of Walnut, circa 1940s. Some of the storefronts are Loew's Midland Theater, Newman Theater, Gateway, and Jones.

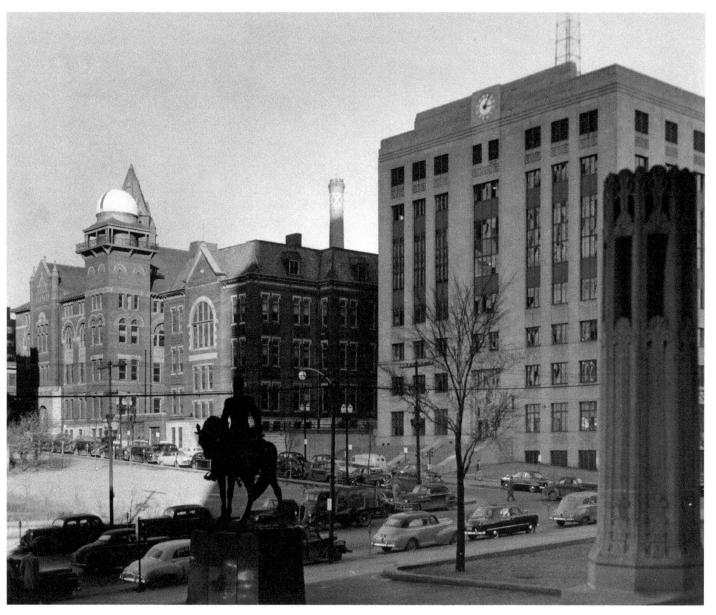

A 1945 photograph taken from the steps of the Jackson County Courthouse showing Police Headquarters (1125 Locust), the Junior College of Kansas City, and the Andrew Jackson statue.

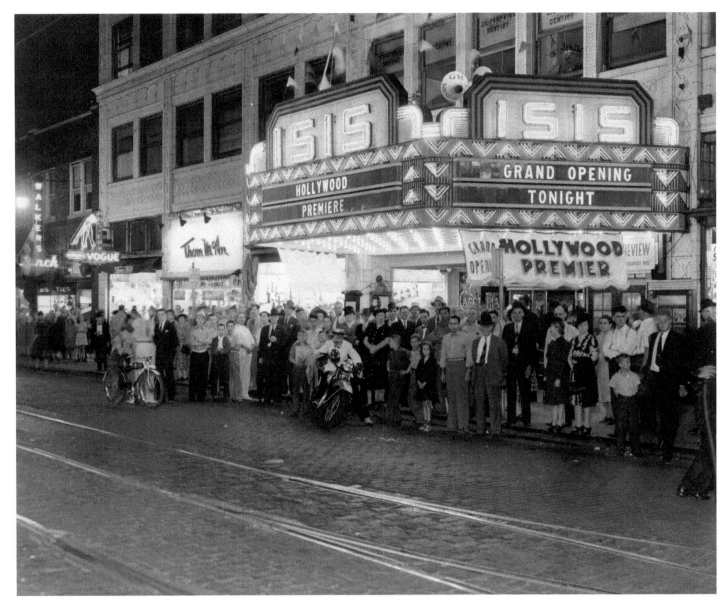

A crowd gathers underneath the Isis Theater marquee at 31st and Troost in 1945.

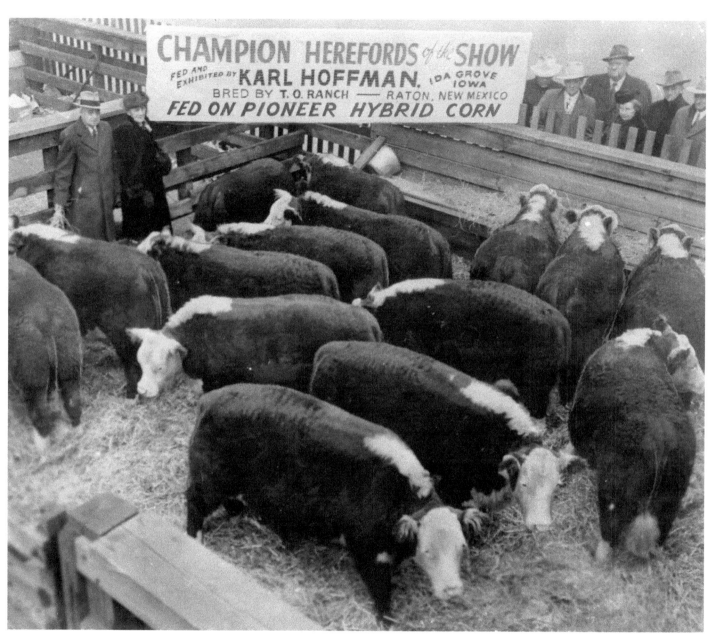

A view of the "Champion Herefords of the Show" in a Kansas City livestock pen, 1945.

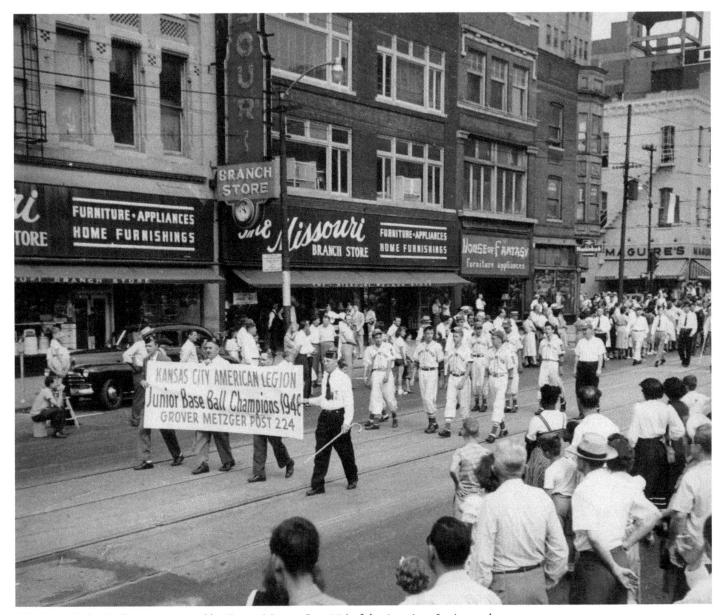

Members of a baseball team sponsored by Grover Metzger Post 224 of the American Legion and members of the post are marching south along Grand Avenue in a 1948 parade. The post members are carrying a sign that identifies the team as "Junior Base Ball Champions 1948."

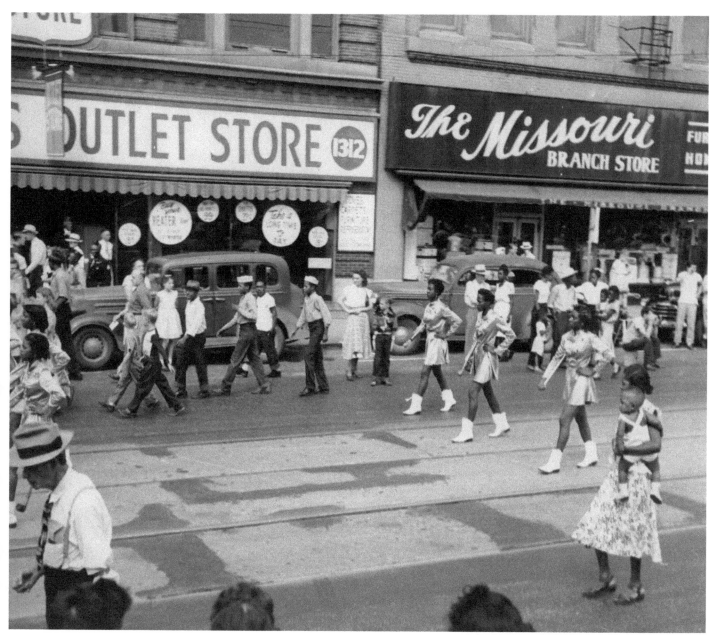

Baton twirlers are marching south on Grand Avenue in a 1948 parade.

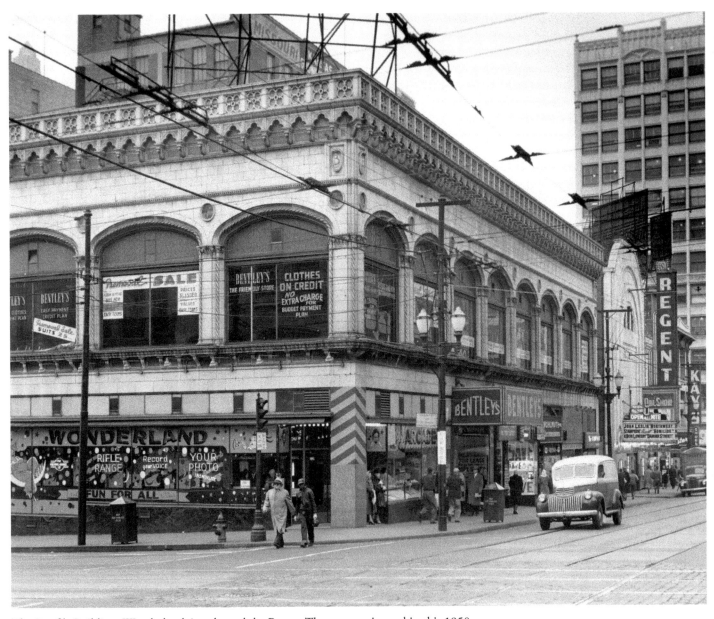

The Bonfils Building, Wonderland Arcade, and the Regent Theater are pictured in this 1950 photograph of the corner of 12th and Grand Avenue.

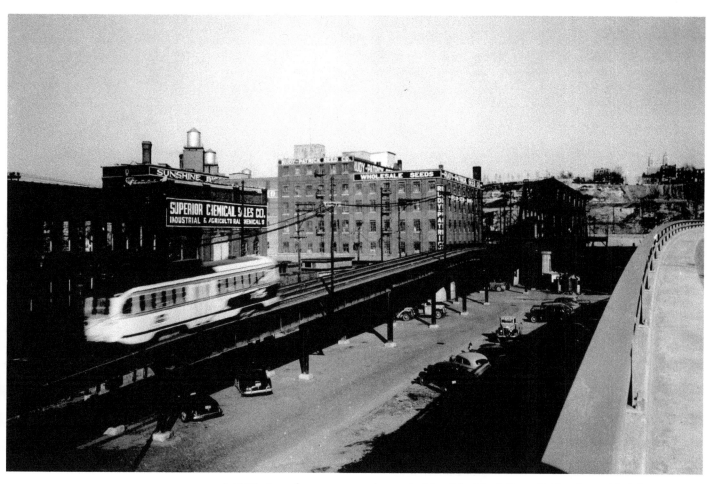

A 1950 view of a streetcar on the south side of the Ninth Street Bridge, located in West Bottoms.

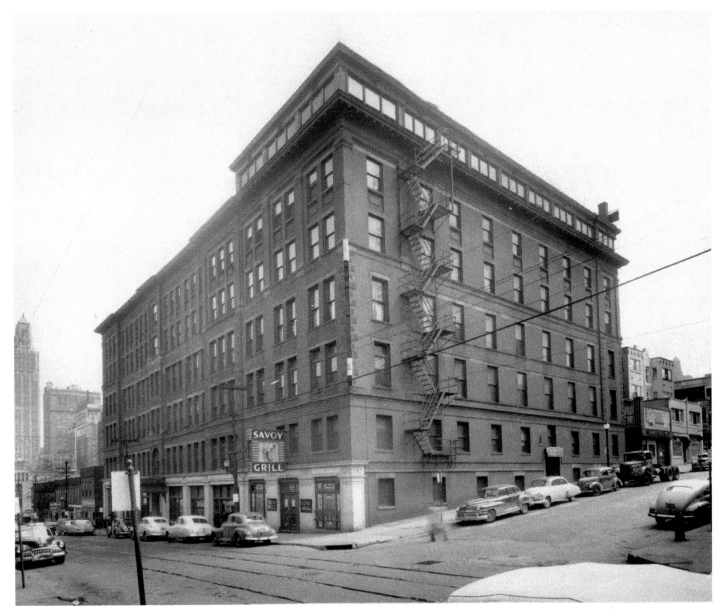

The Savoy Hotel, pictured here in 1950, is located at 219 W. Ninth Street. The Hotel was built in 1888.

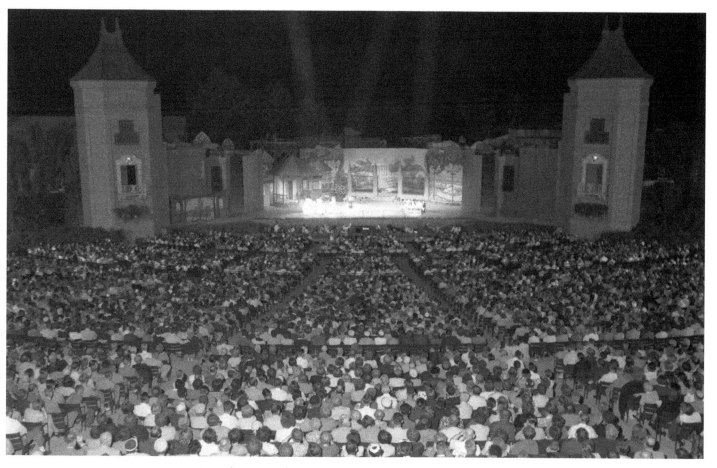

An audience watching one of the many great productions at Kansas City's Starlight Theatre. Although not quite finished, Starlight opened in 1950 for the celebration of Kansas City's centennial. It is one of only three remaining self-producing outdoor theaters in the country today.

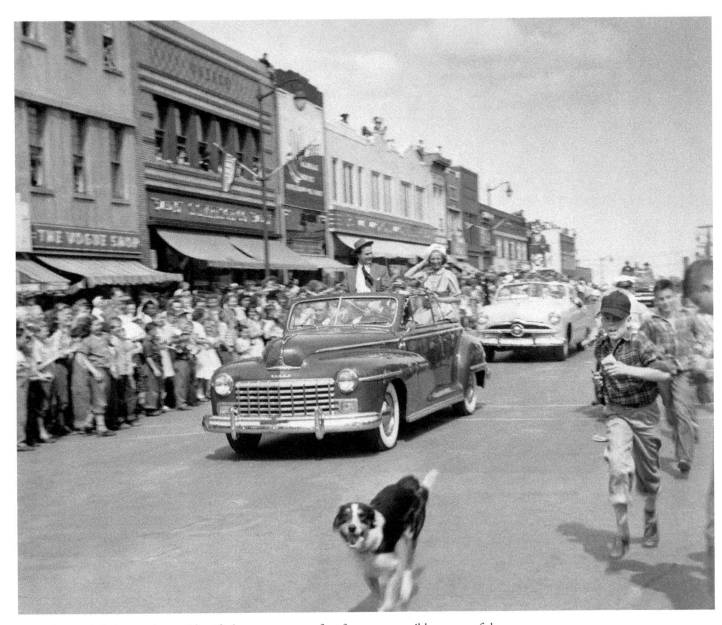

Comedian Red Skelton and an unidentified woman wave to fans from a convertible as part of the Kansas City Centennial Celebration in 1950.

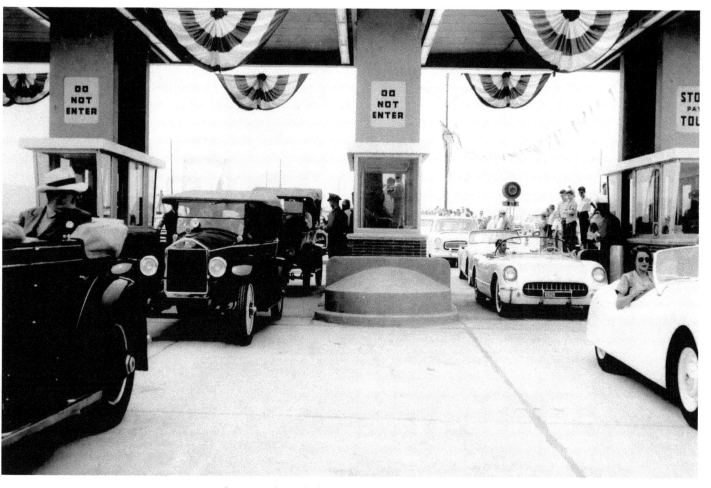

Cars pass through the toll gates at the northern end of the Paseo Bridge during its dedication on August 13, 1954.

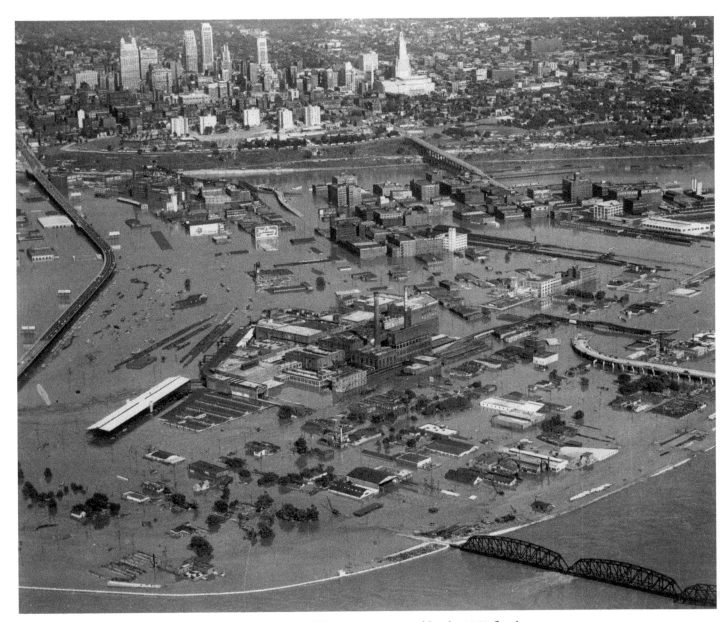

An aerial view of the damage to downtown Kansas City and West Bottoms caused by the 1951 flood. The view is looking toward the east from near the confluence of the Missouri and Kansas rivers. The Intercity Viaduct is on the left, and the Kansas River is at bottom.

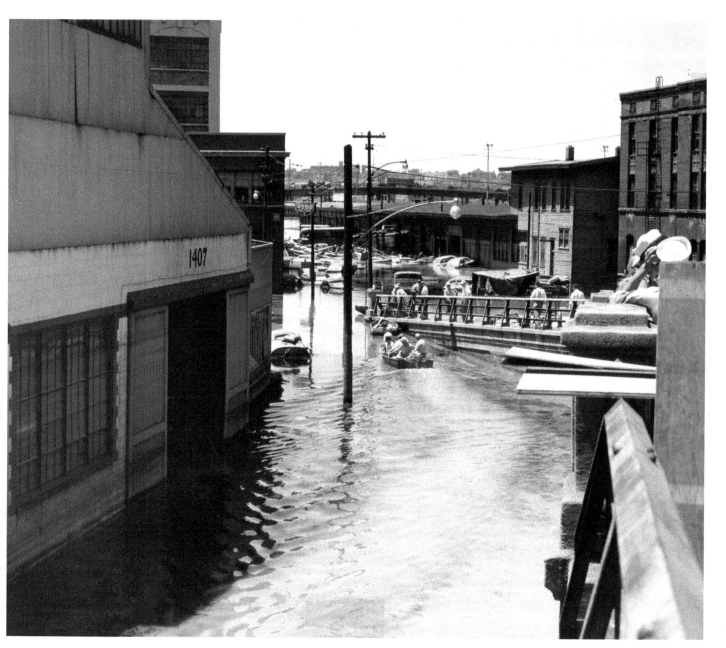

A view of the destruction in Kansas City caused by the 1951 flood.

The six-story masterpiece built in 1927, Midland Theater, is pictured here in 1955.

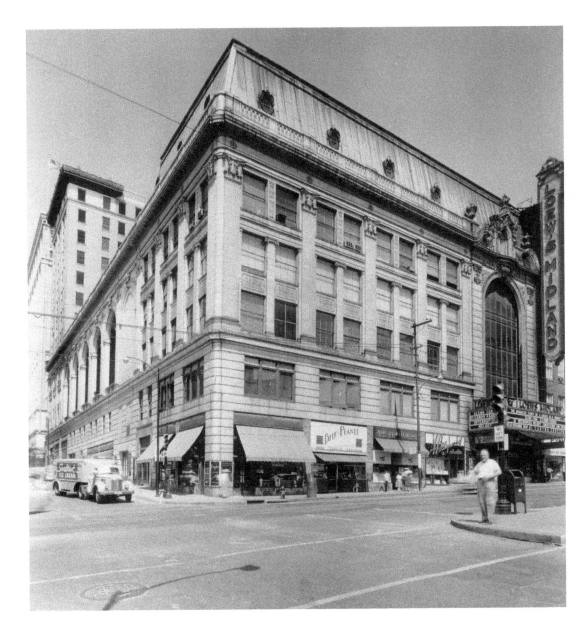

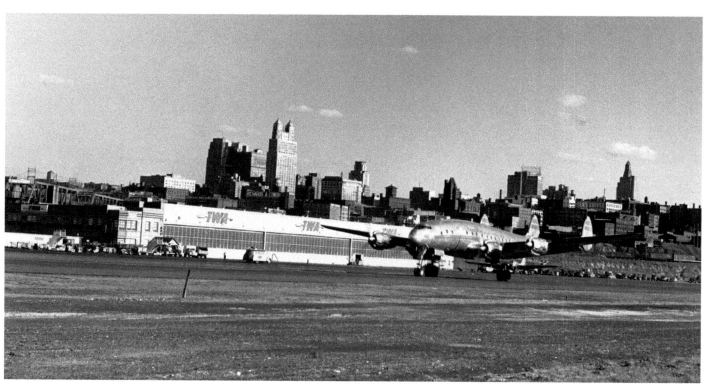

A view of a plane taxiing at the Kansas City Municipal Airport with TWA signs seen in the background.

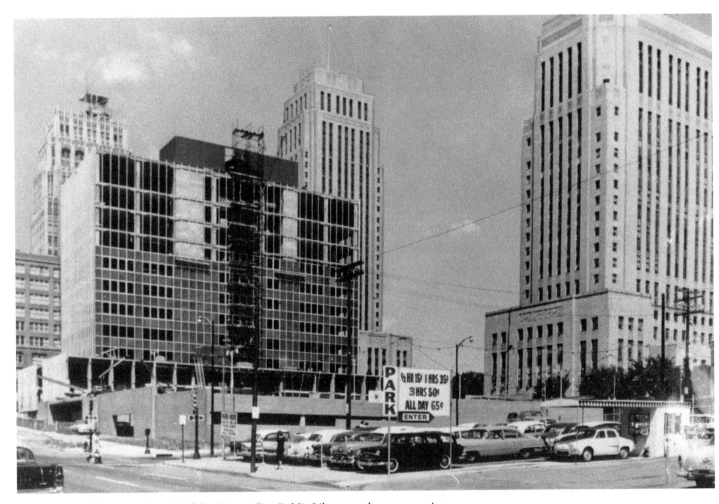

A 1960 view of the Main branch of the Kansas City Public Library under construction.

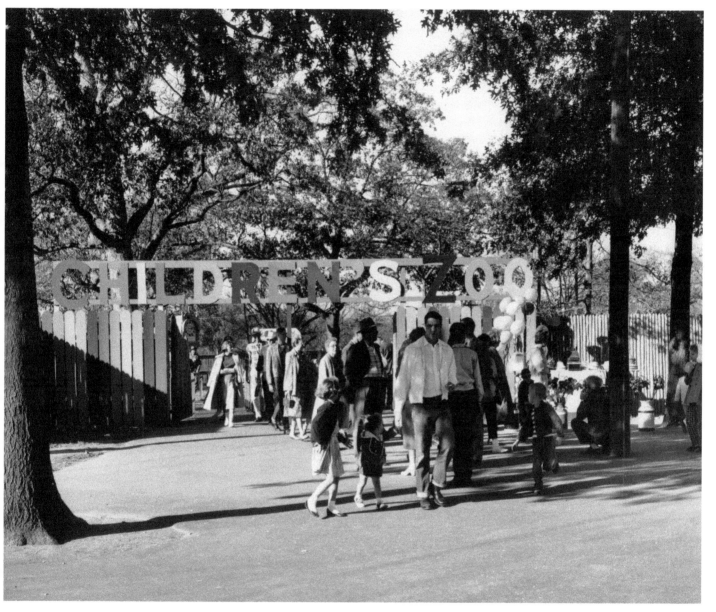

A 1960 photograph of a crowd walking through the Children's Zoo in Kansas City.

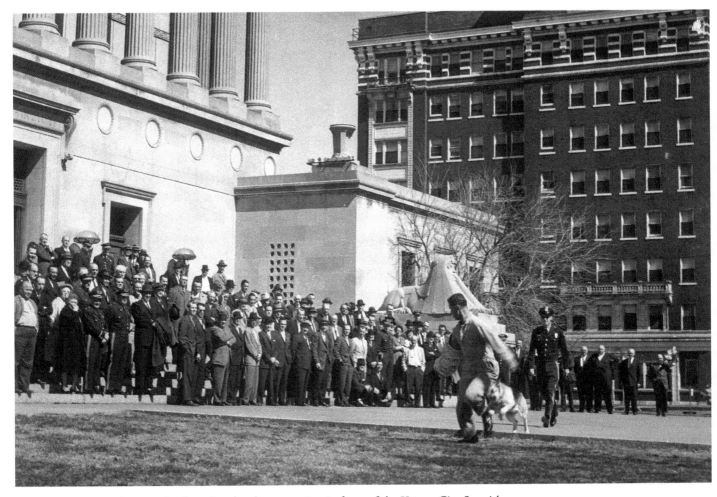

A March 14, 1961, photograph of a police dog demonstration in front of the Kansas City Scottish Rite or World War II Memorial Building, located at Linwood and the Paseo. Mayor H. Roe Bartle is shown watching behind the policeman. The St. Regis Hotel is also pictured, to the right.

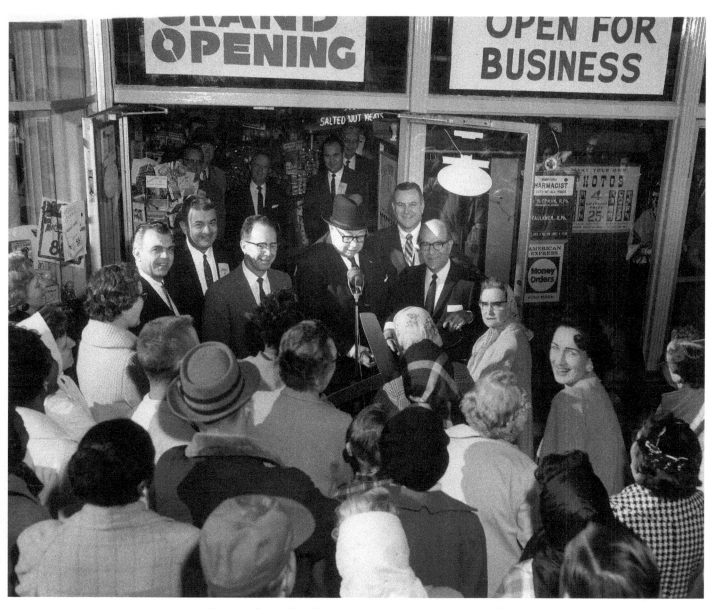

Opening day at Katz Drug Store, located on Linwood and Troost, October 26, 1961. It had recently been remodeled due to a fire. Mayor H. Roe Bartle, President Tony Pettus of the South Central Business Association, and President Morris Shlensky, chairman of the board of the Katz Drug Company are also in the photograph.

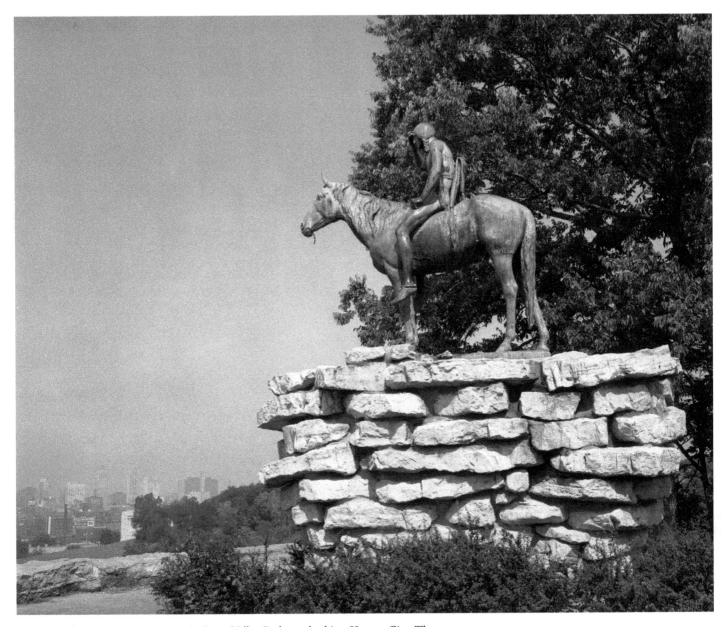

A view of the *Scout* statue as it sits in Penn Valley Park overlooking Kansas City. The statue represents a Sioux on horseback returning from a hunting trip.

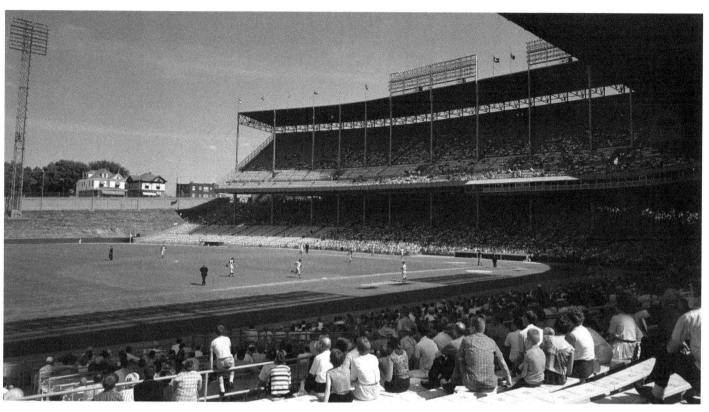

A Kansas City Athletics game is taking place at Municipal Stadium, circa 1960s. The Athletics came to Kansas City in 1955 from Philadelphia and stayed until they moved to Oakland, California, in 1968.

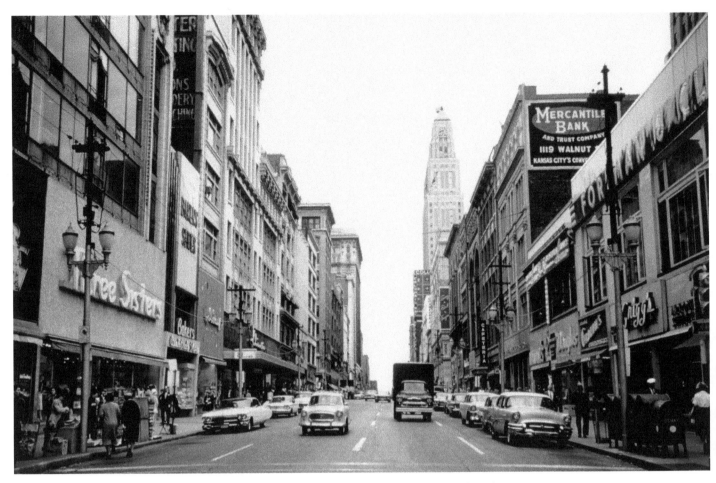

From 12th Street, a view of Walnut Street looking north in downtown Kansas City, May 16, 1961.

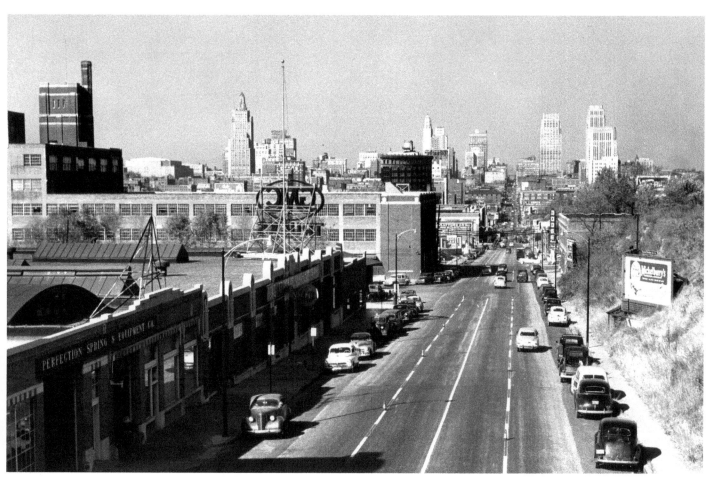

A downtown view of Kansas City, circa early 1960s.

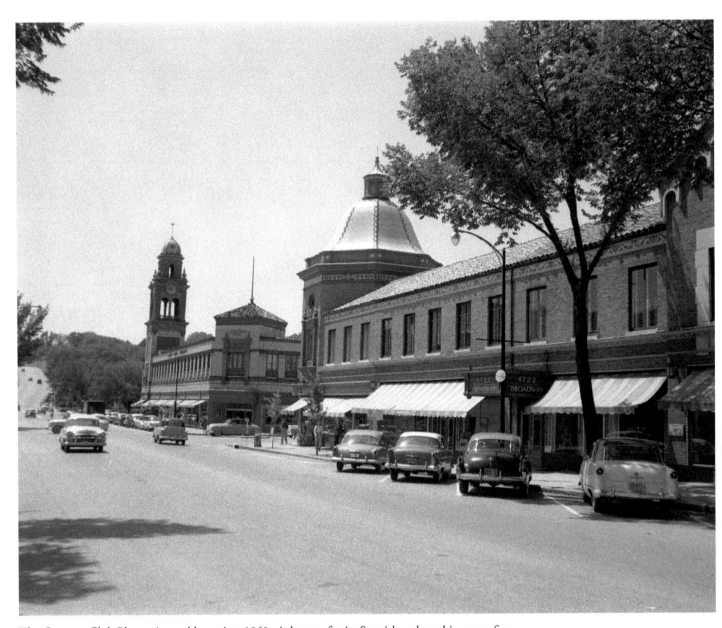

The Country Club Plaza, pictured here circa 1960s, is known for its Spanish-style architecture, fine shopping, restaurants, and hotels, as well as many statues and fountains. The clock tower is visible in the background.

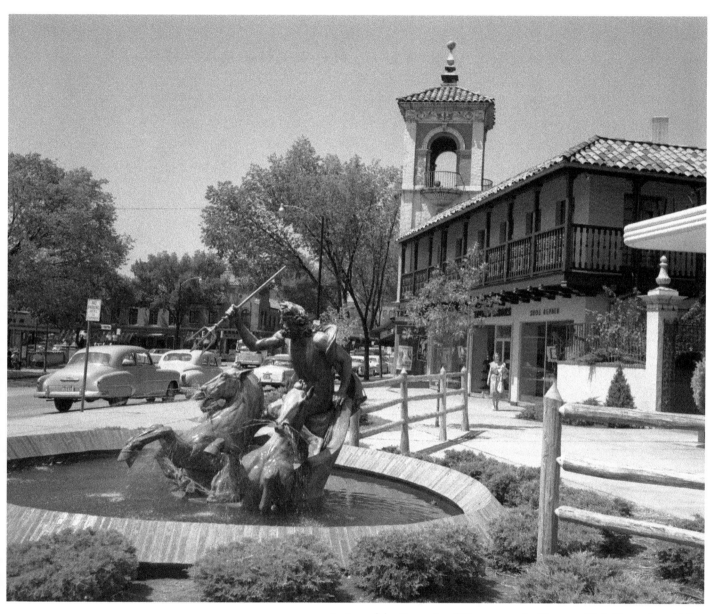

A view of the Fountain of Neptune at the Country Club Plaza, circa 1960s.

Notes on the Photographs

These notes, listed by page number, attempt to include all aspects known of the photographs. Each of the photographs is identified by the page number, a title or description, photographer and collection, archive, and call or box number when applicable. Although every attempt was made to collect all data, in some cases complete data may have been unavailable due to the age and condition of some of the photographs and records.